THE ANDREW PROJECT

1000 and Something Portraits
in Toronto, Berlin and London,
2010 – 2013

SHAAN SYED

For us

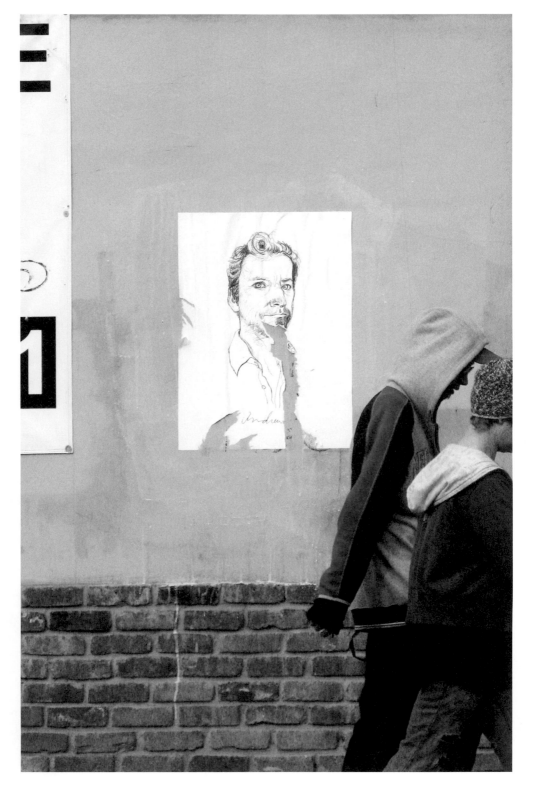

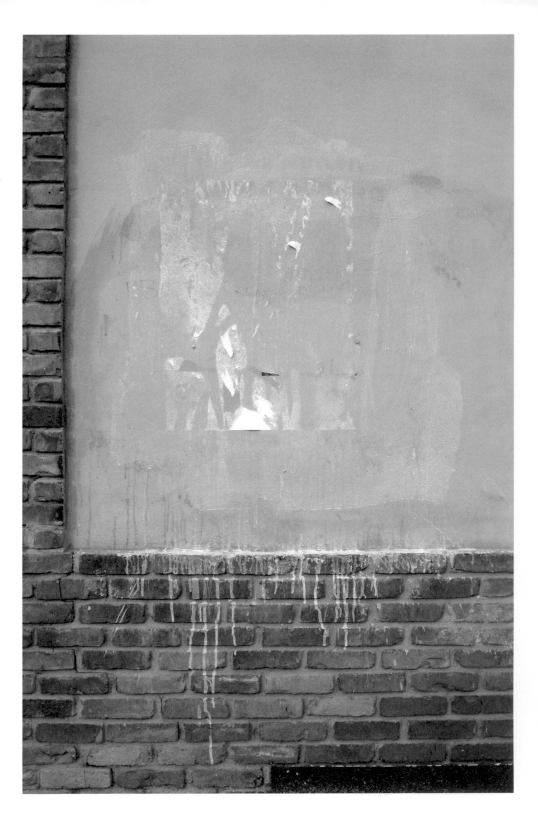

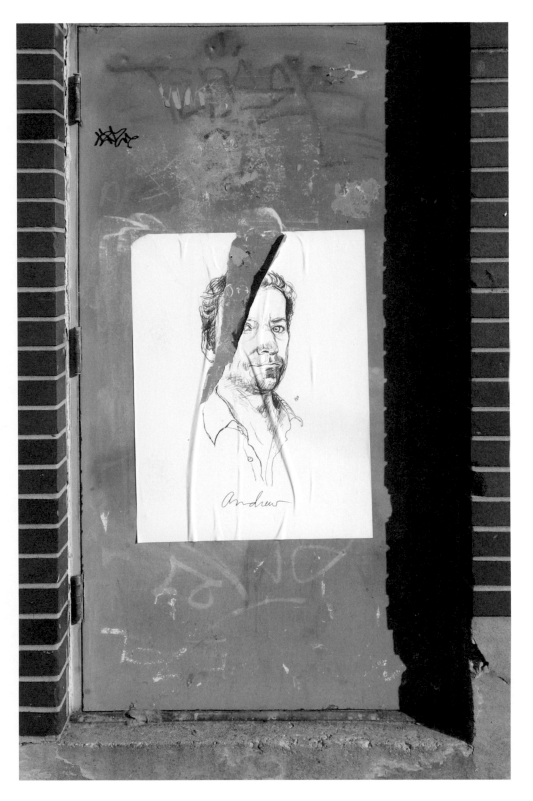

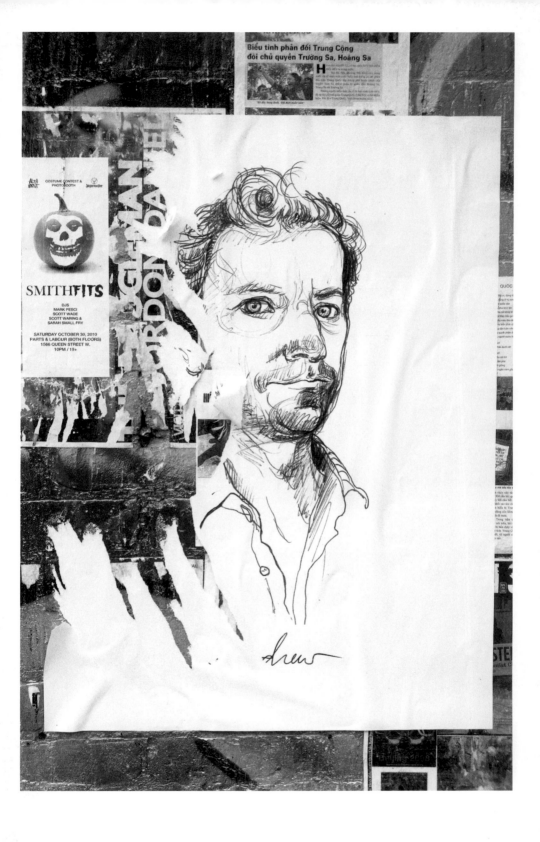

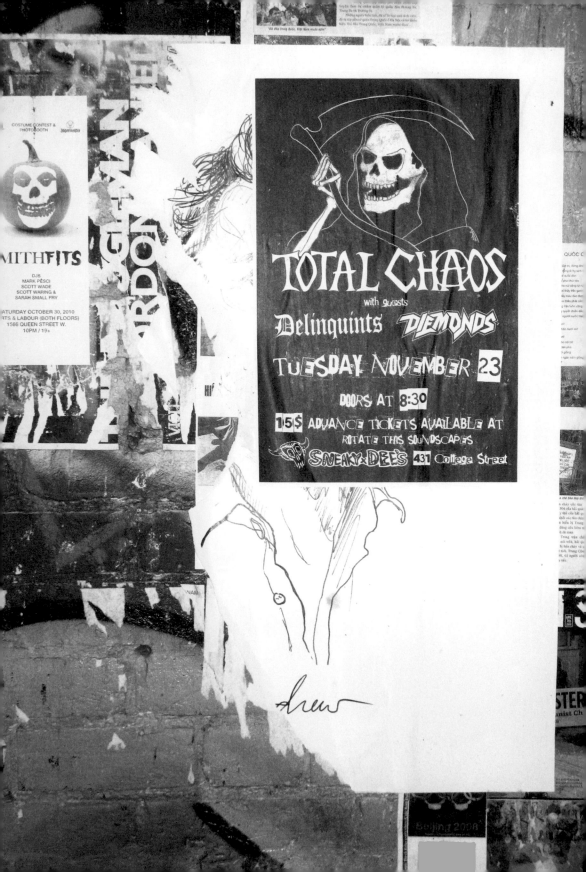

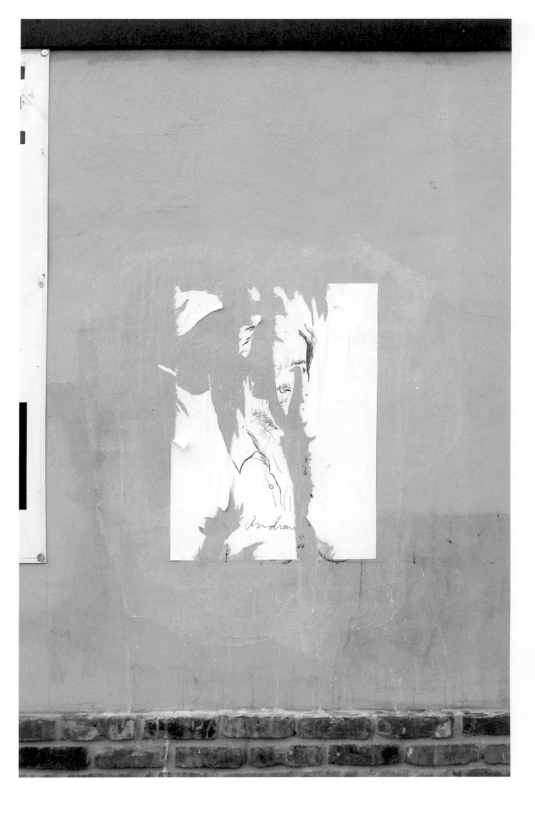

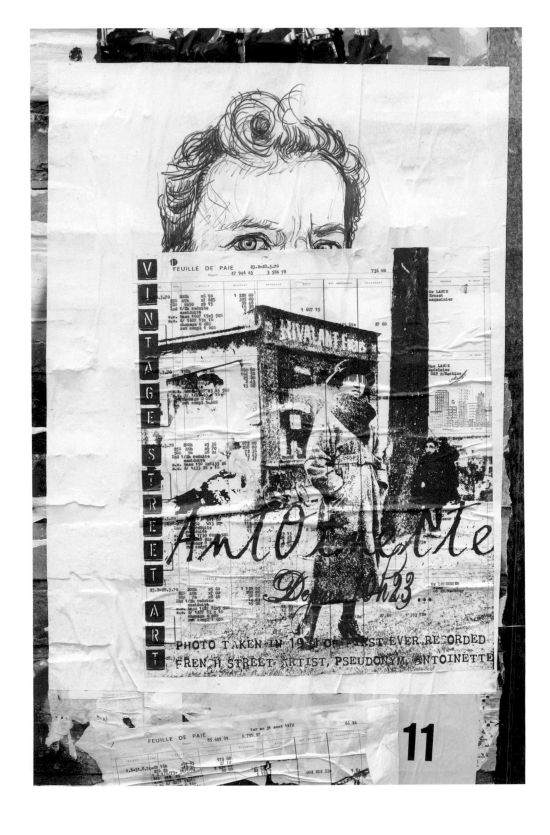

VINTAGE STREET ART

PHOTO TAKEN IN 1931 OF FIRST EVER RECORDED FRENCH STREET ARTIST, PSEUDONYM, ANTOINETTE

I JESUS BUDDHA

AM EACH

U YOU OTHER YOU

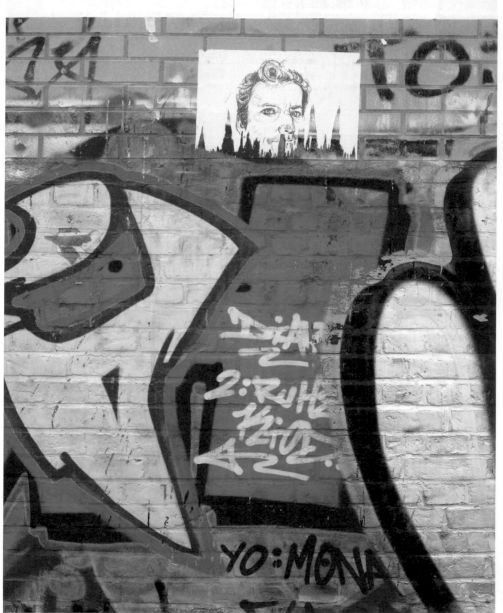

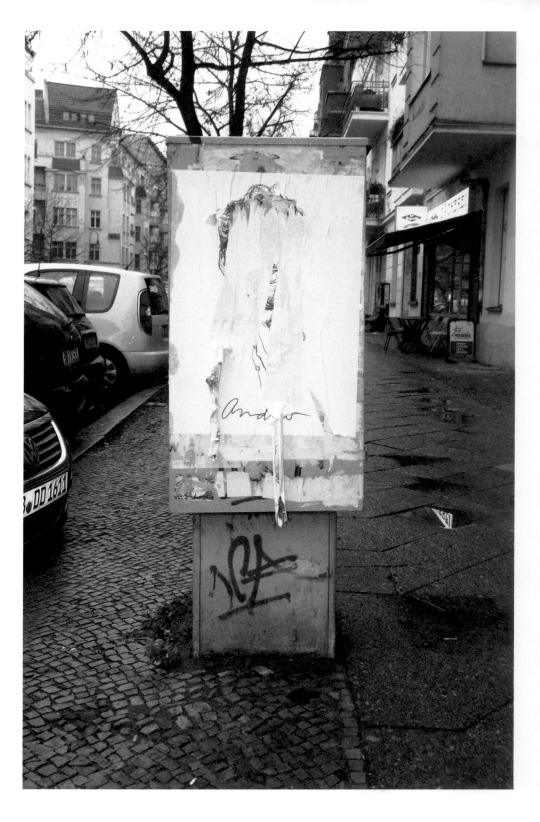

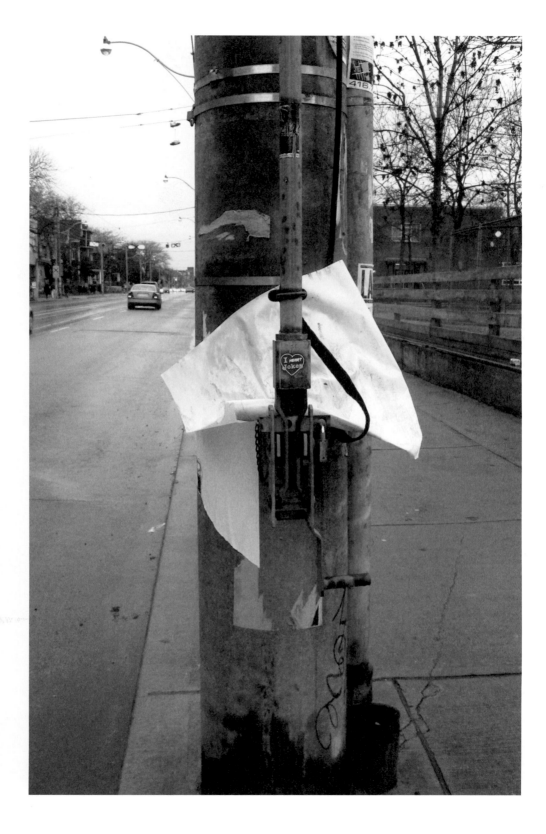

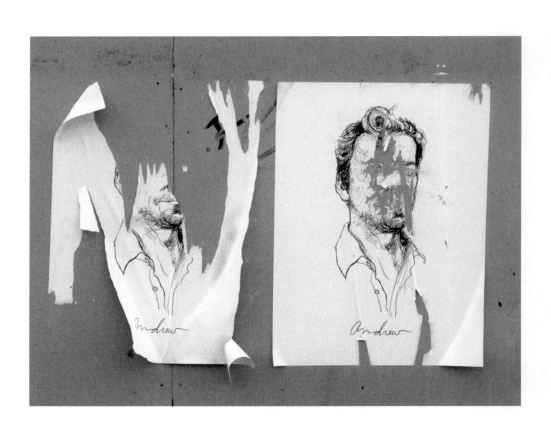

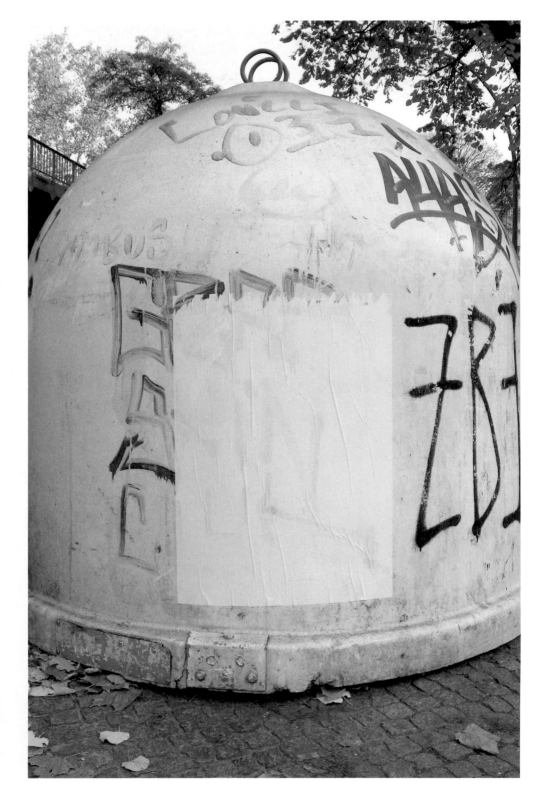

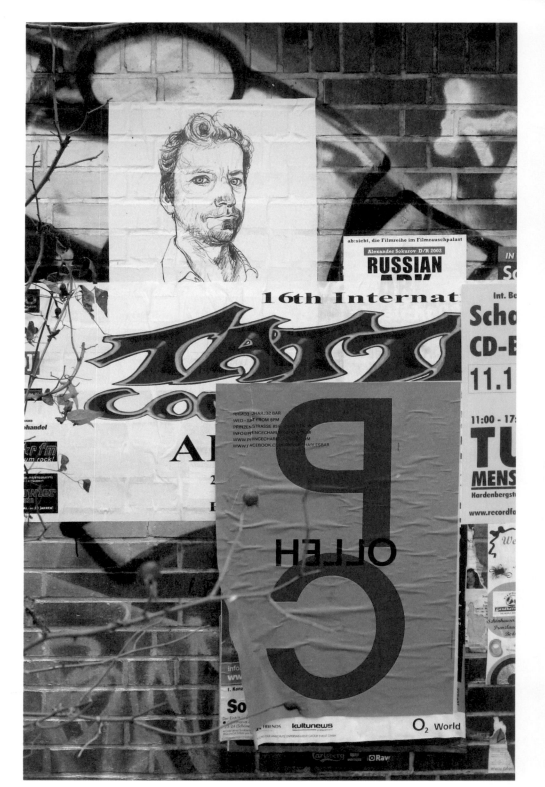

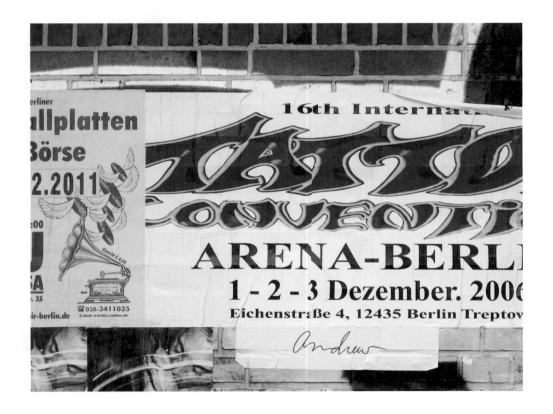

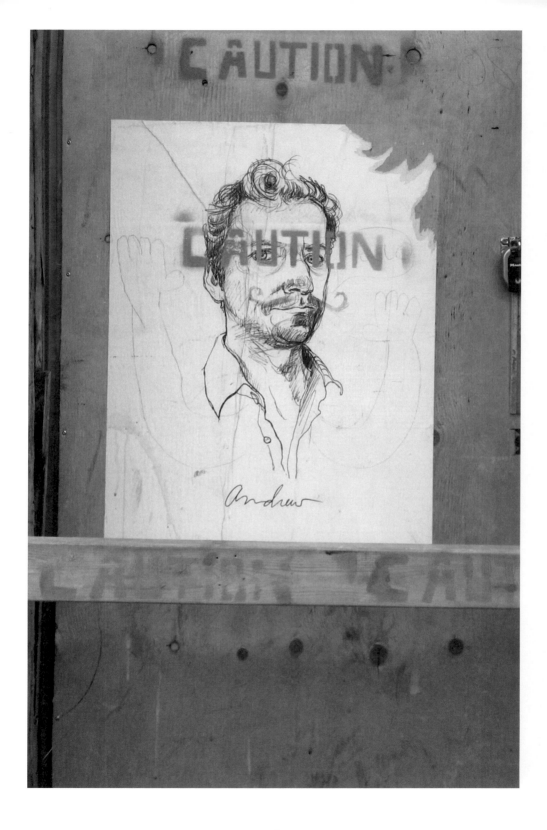

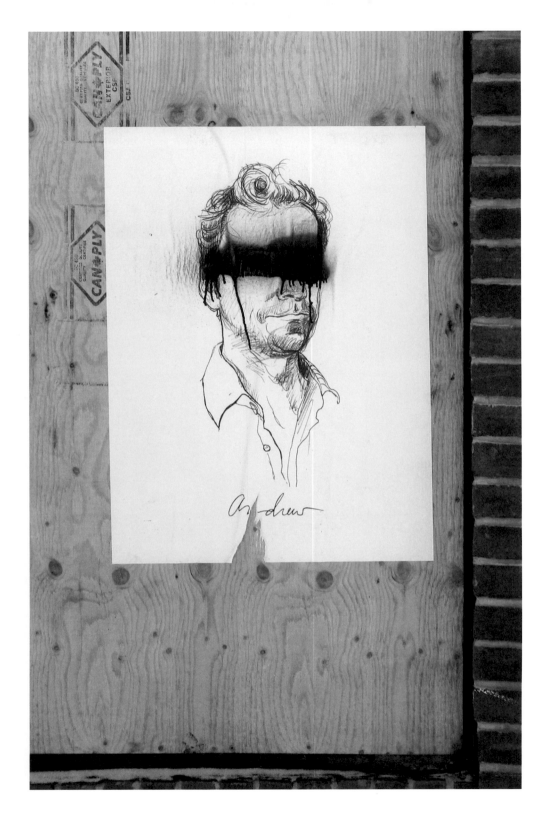

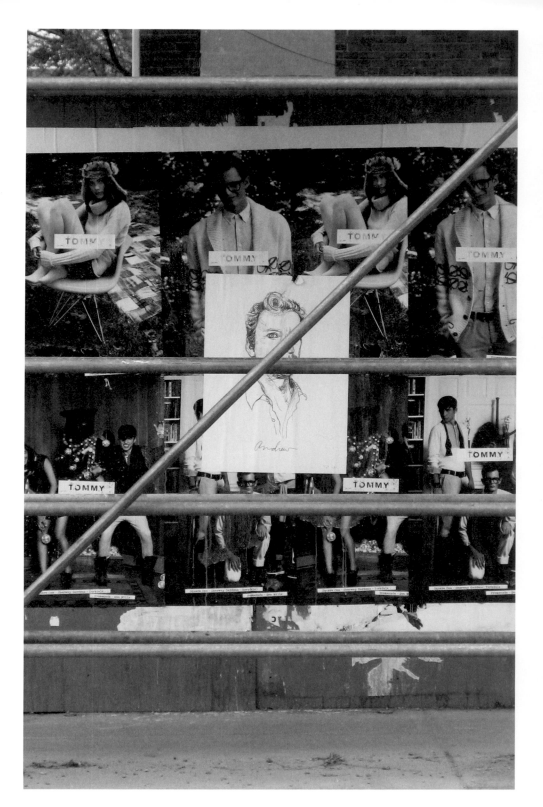

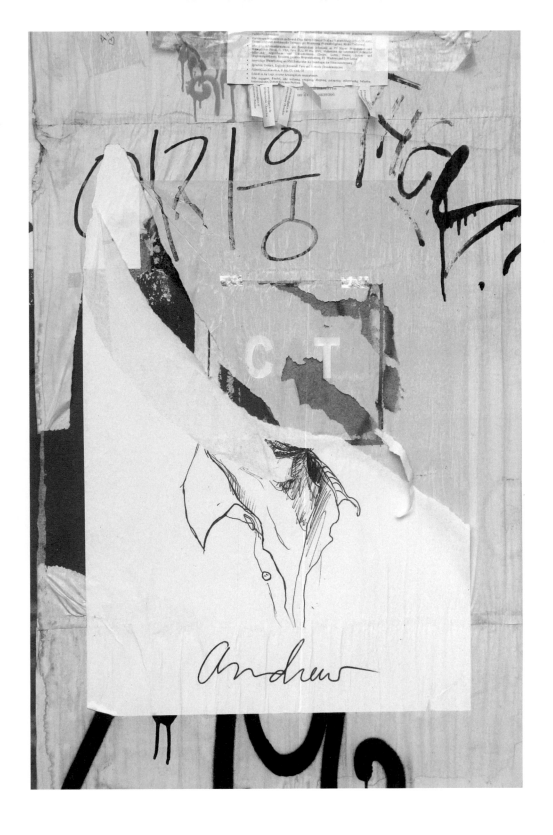

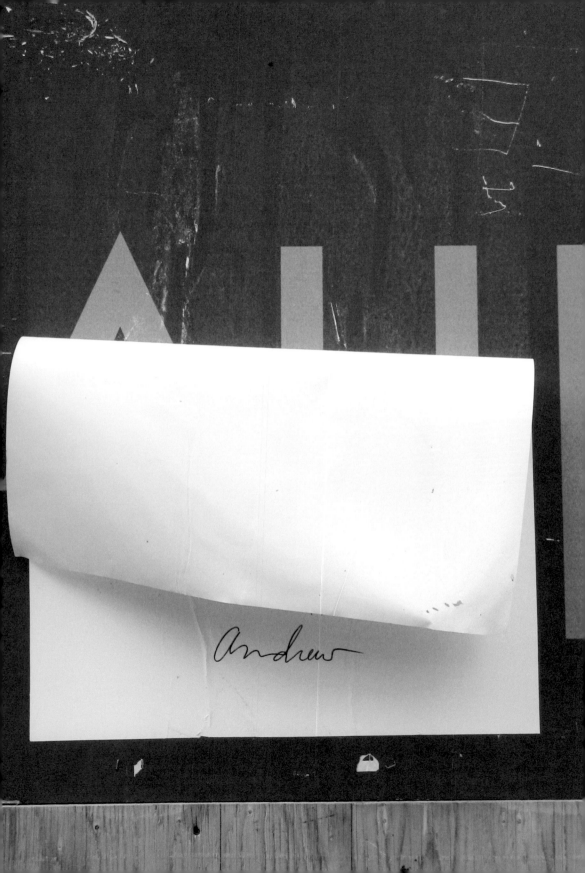

ET

CLU
CL
KASS
MA
PASO
OS
LORD
PO
BON
FA
KLUB

oye
records

FR.16.12." SUICIDE CIRCUS
S+U-BAHNHOF WARSCHAUER STRASSE / ZUGANG DIREKT AN DER WARSCHAUER BRÜCKE
CLUB FLOOR:
LAKKER AUDIO VISUAL LIVE SHOW
JAMES T. COTTON
DJ FLUSH / AXIOM
HOLEFLOOR:
SNITCH / MIRIAM SCHULTE

WWW.KILLEKILL.COM

Andrew

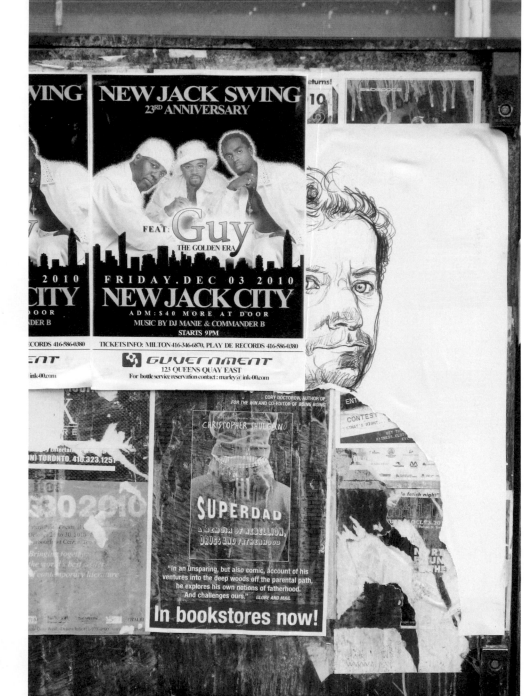

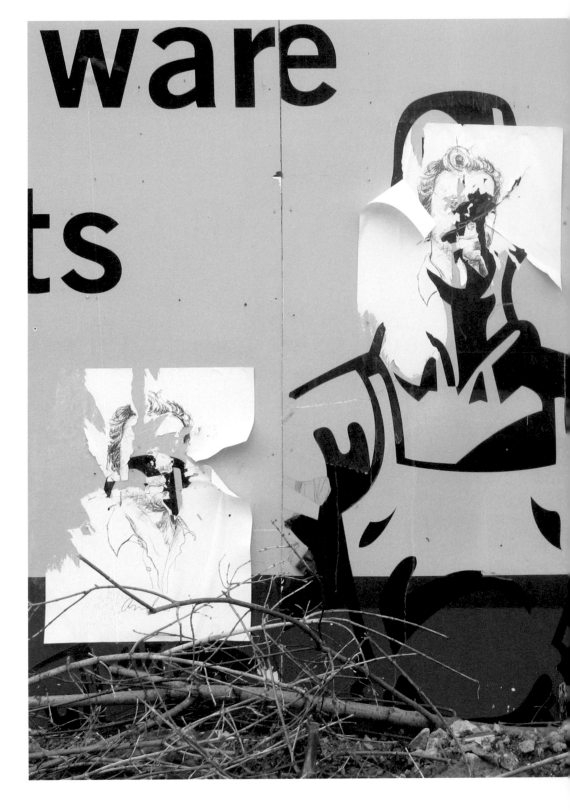

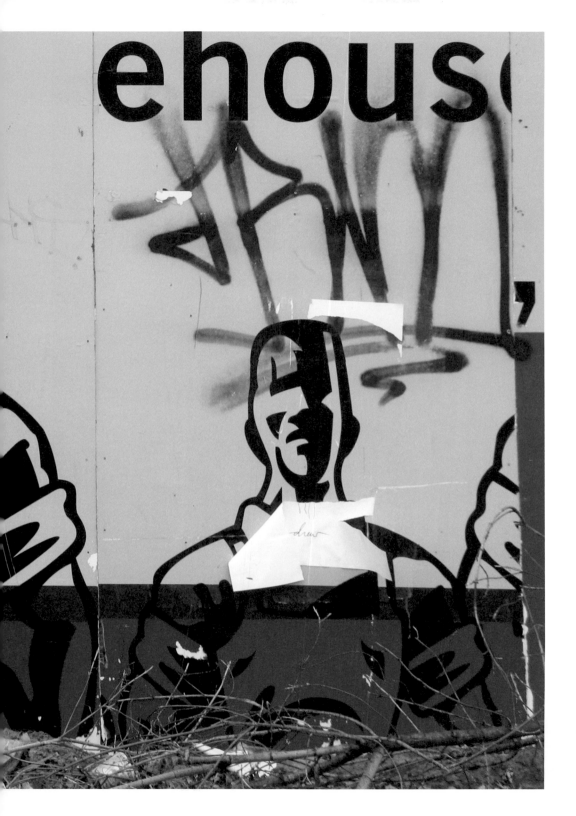

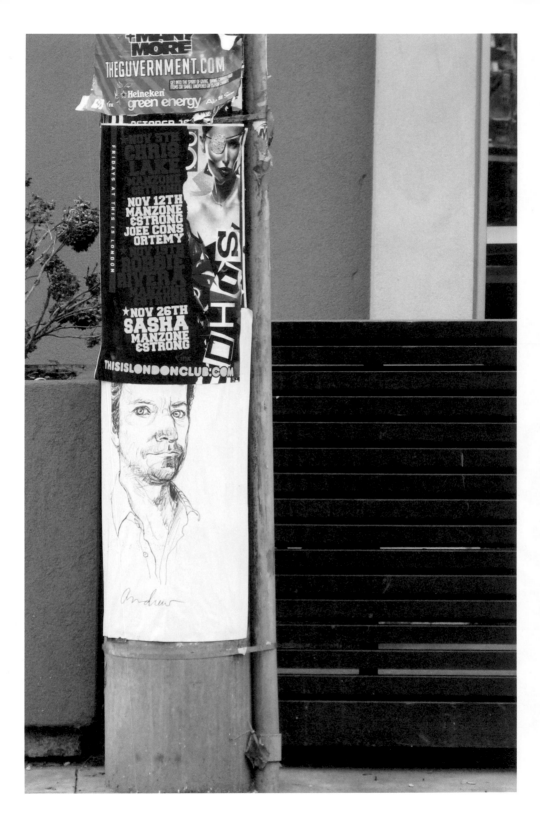

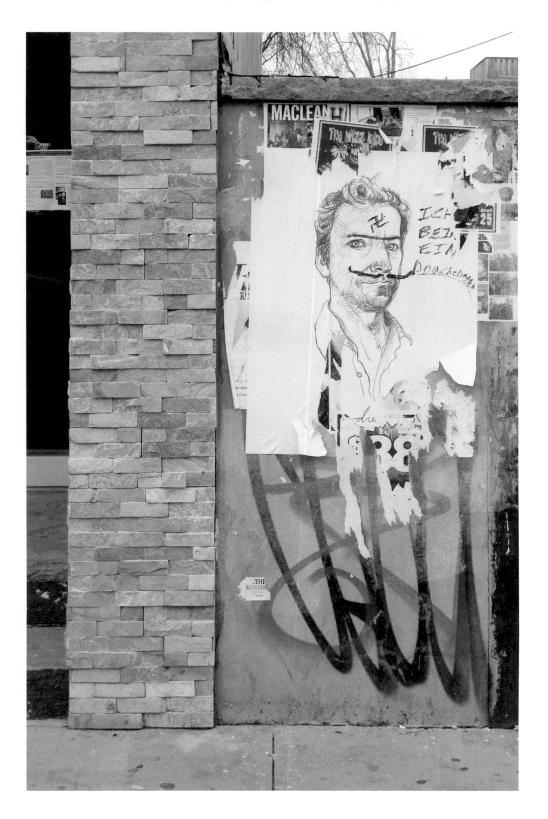

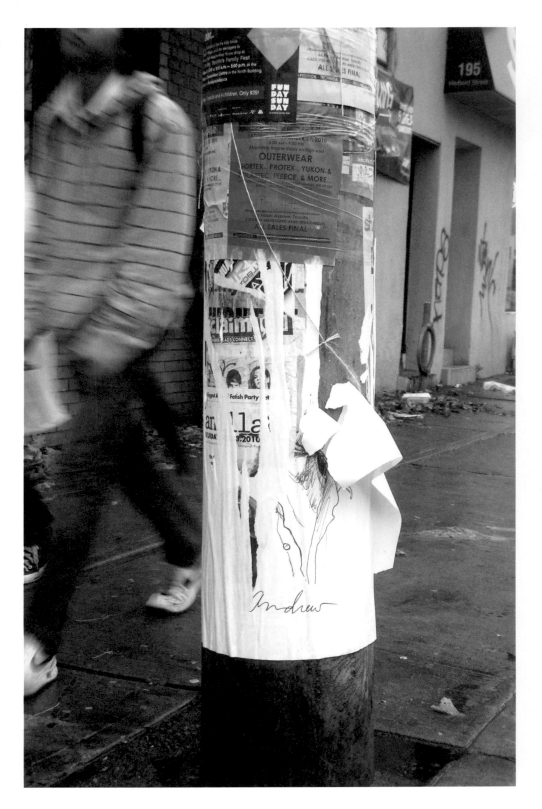

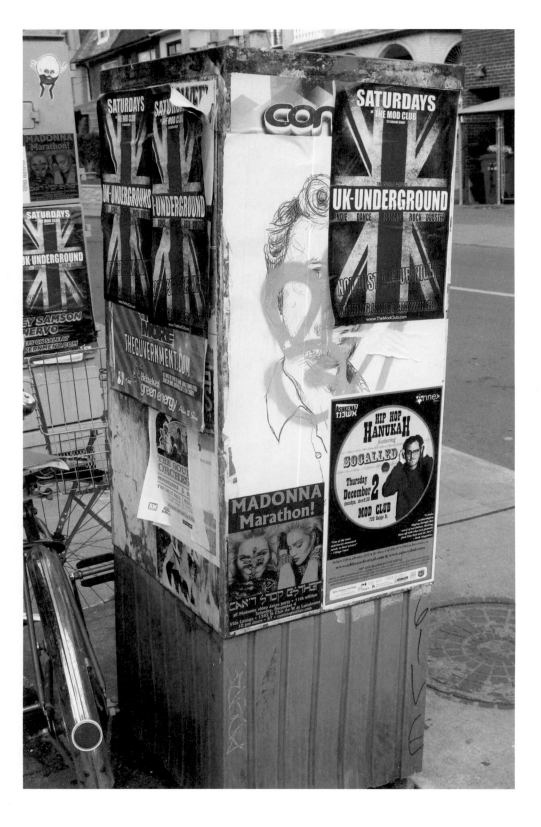

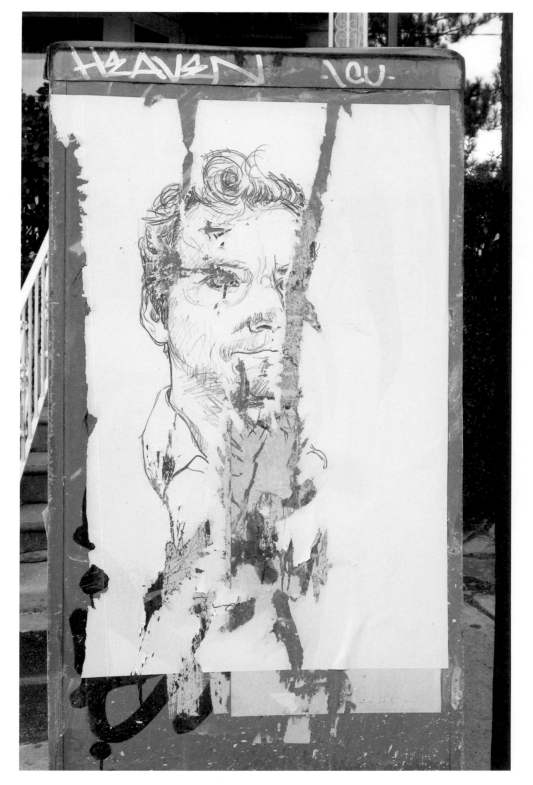

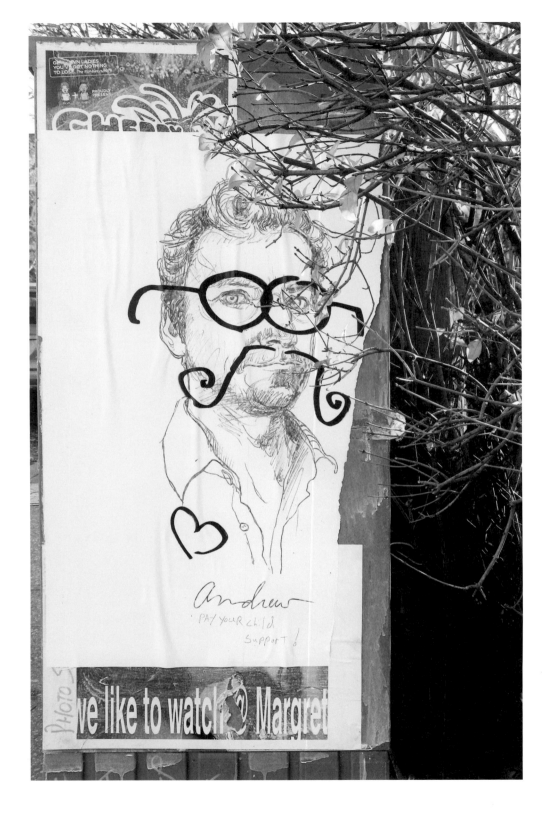

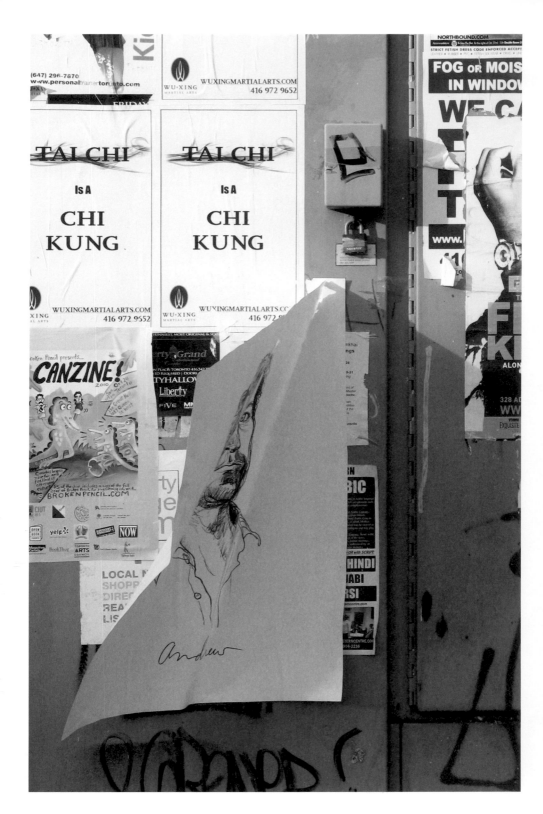

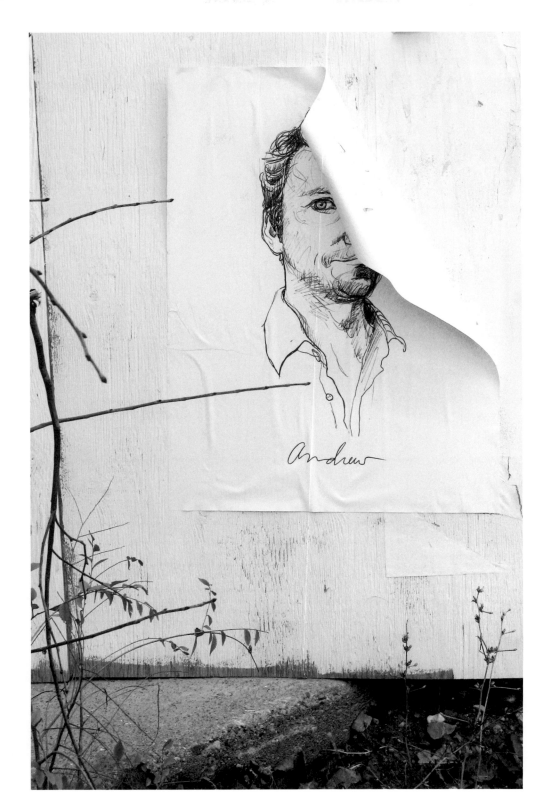

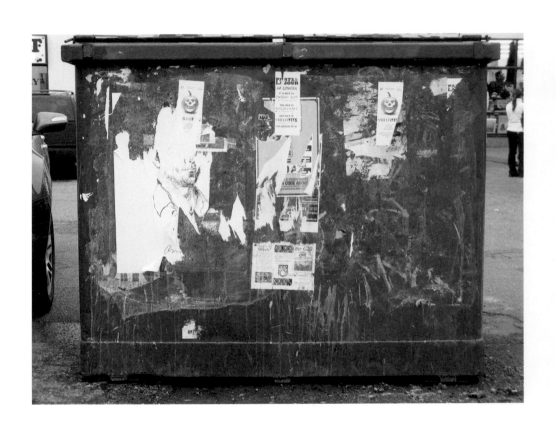

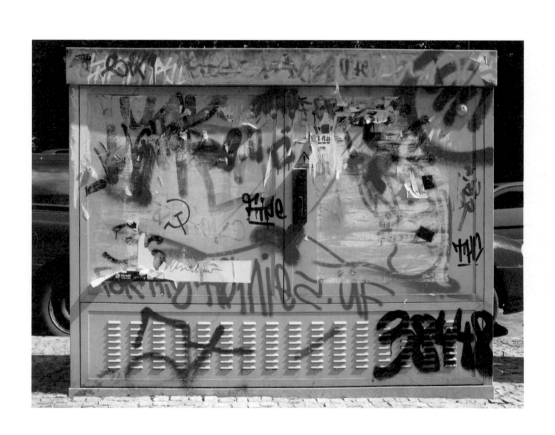

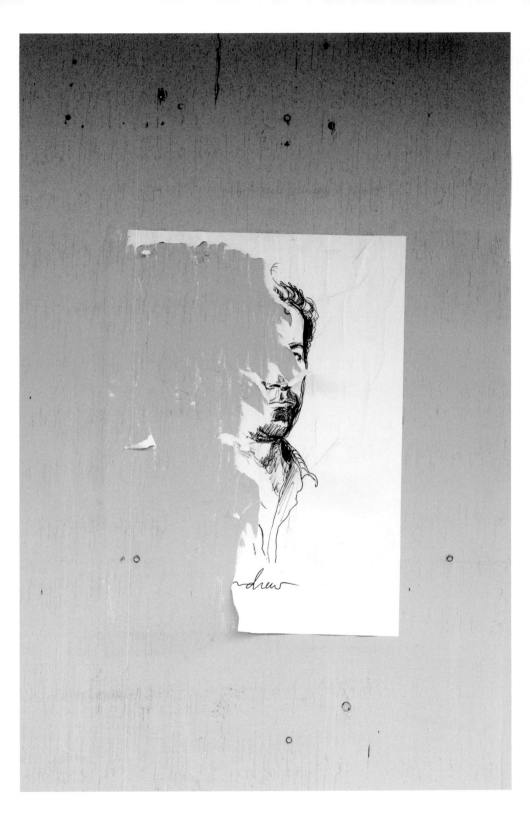

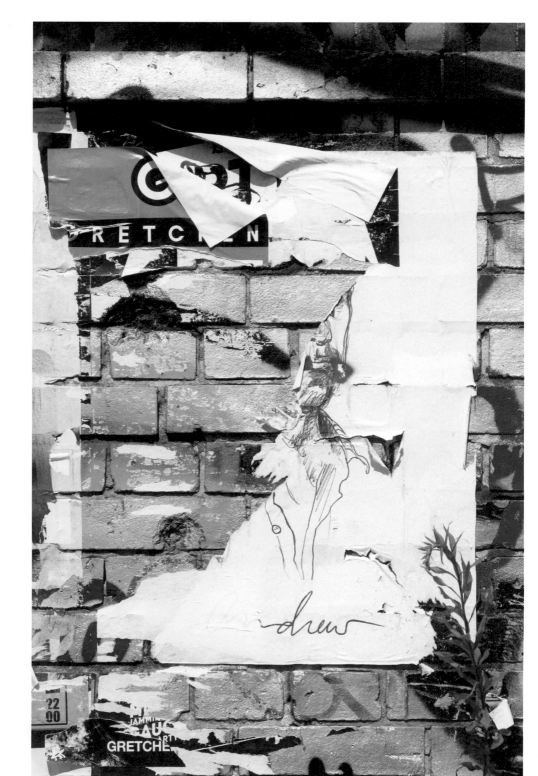

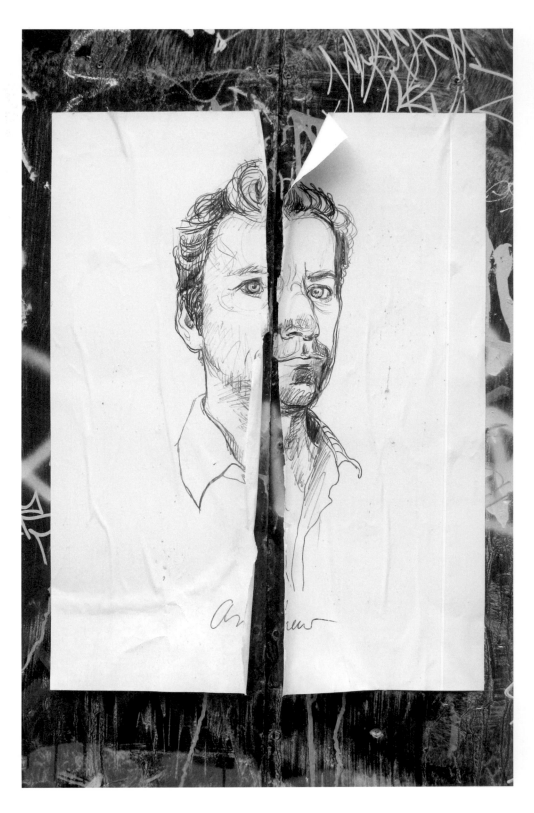

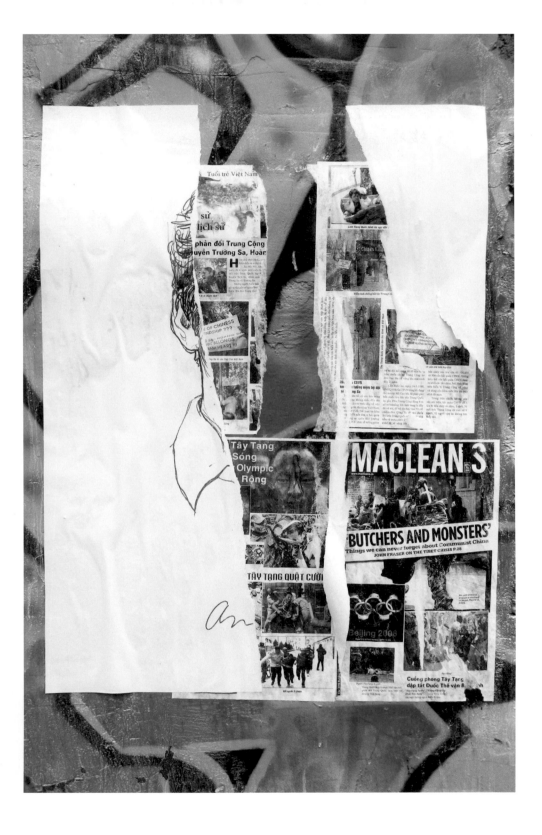

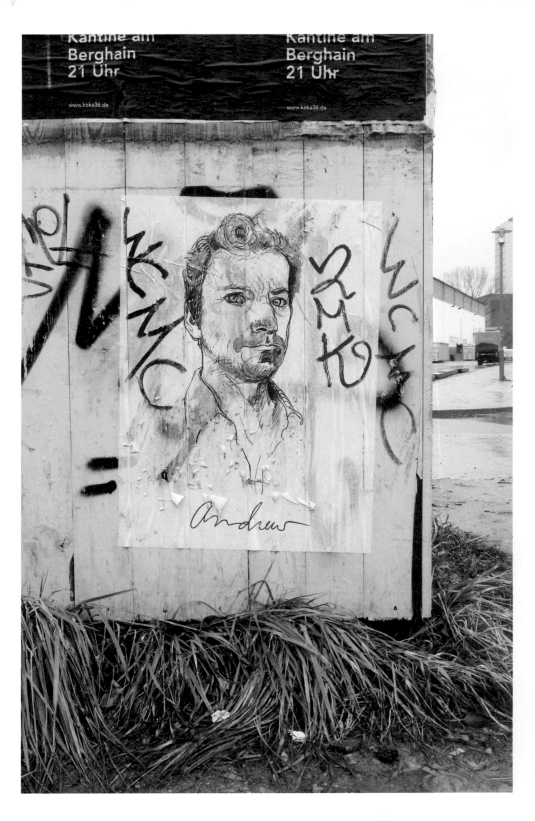

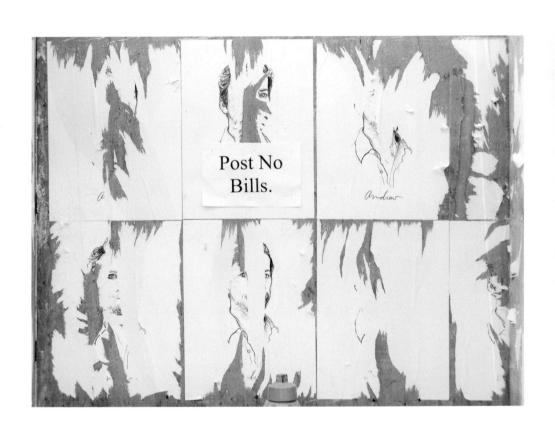

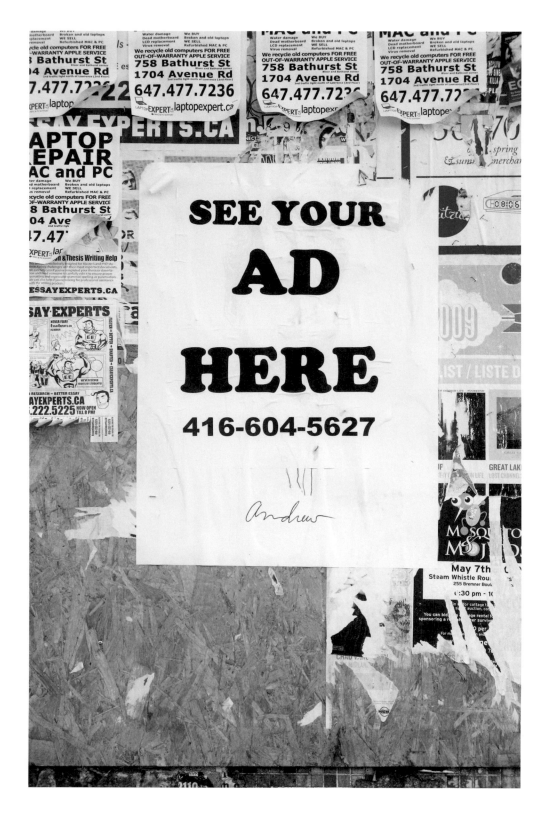

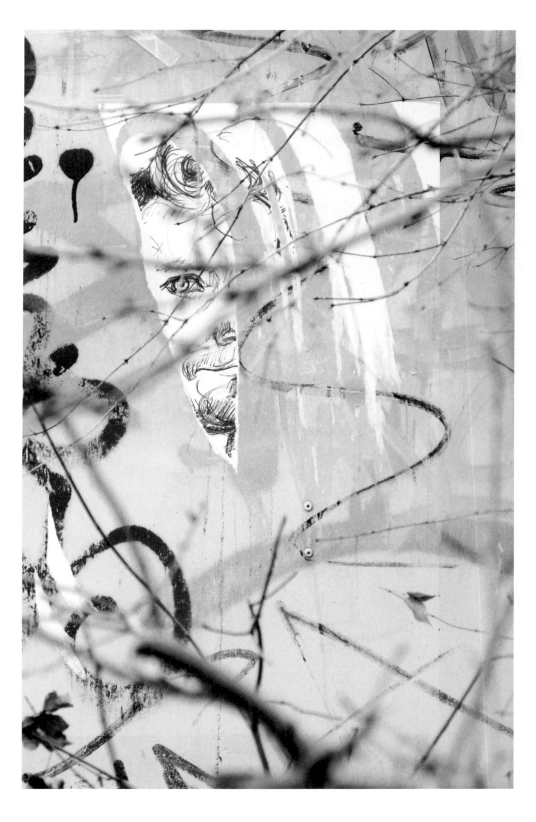

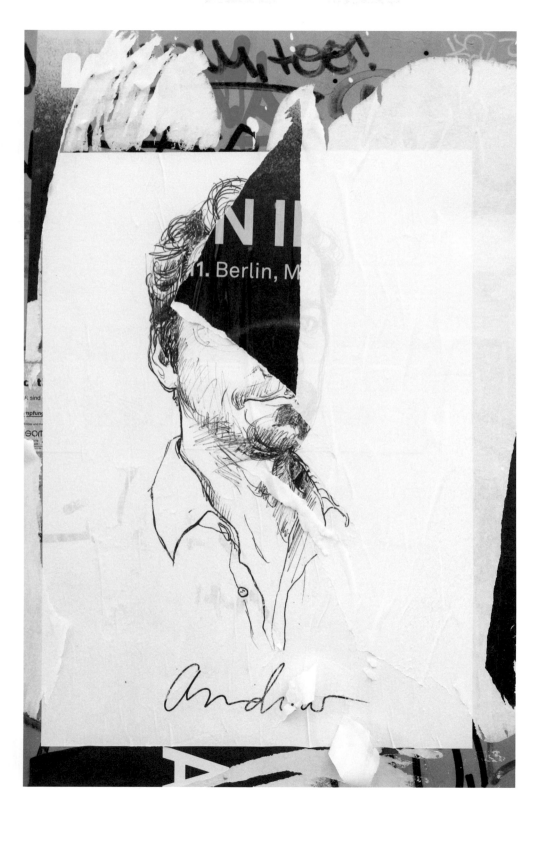

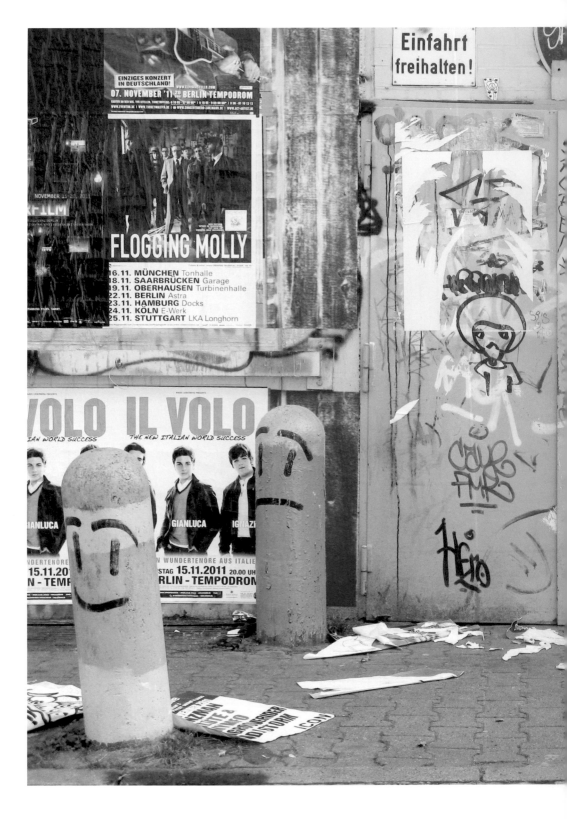

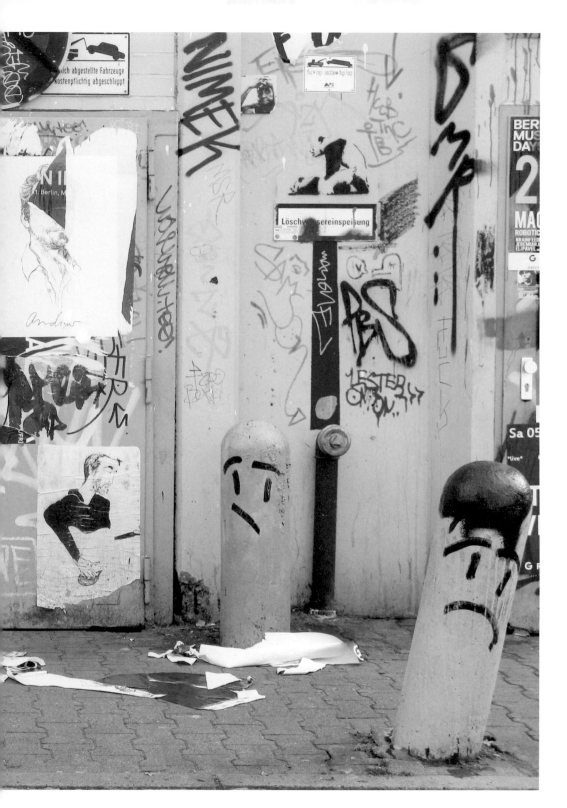

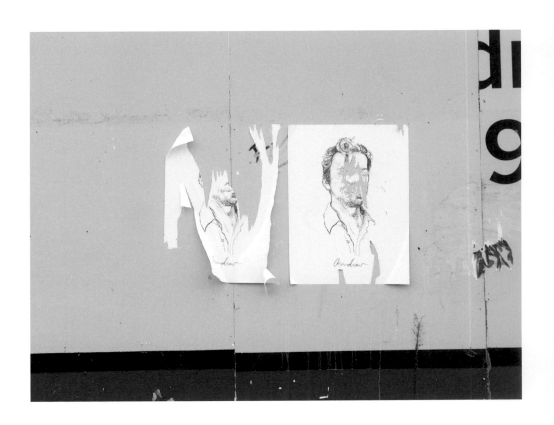

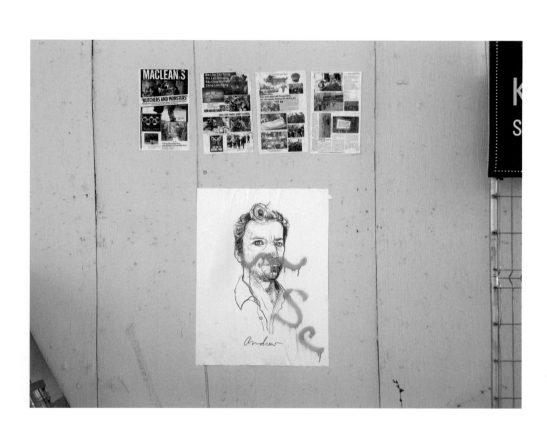

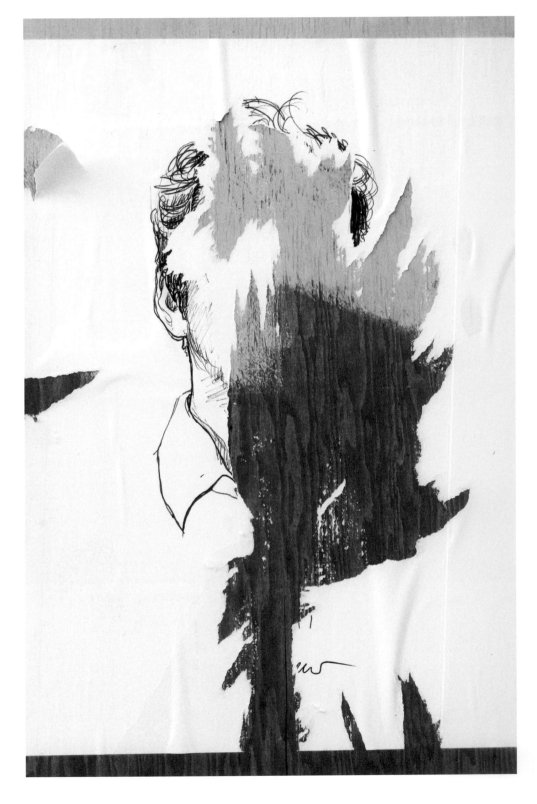

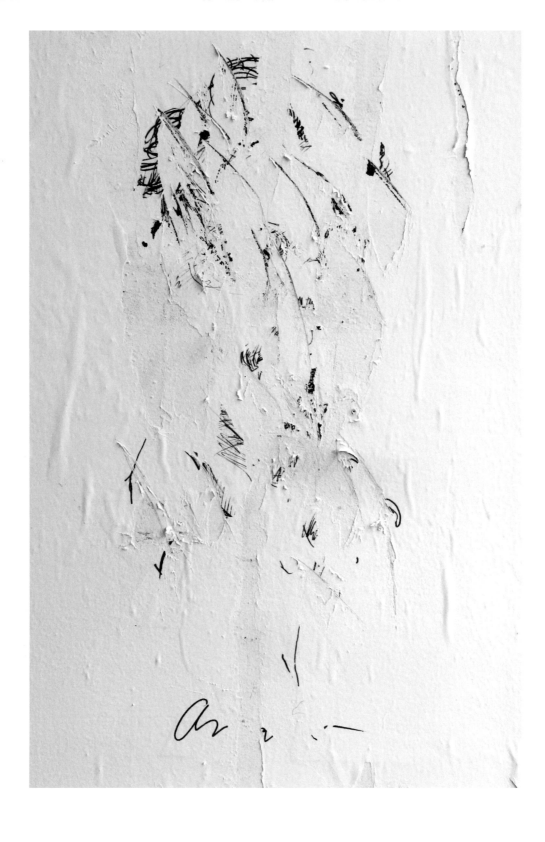

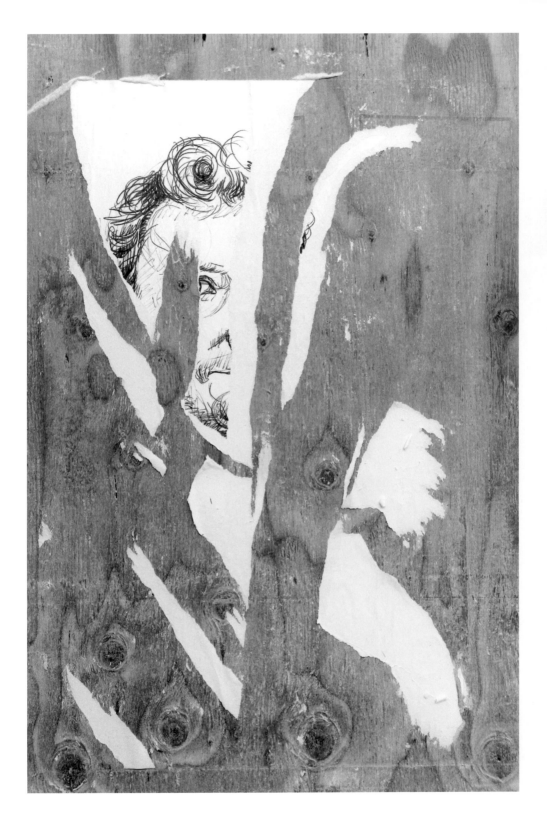

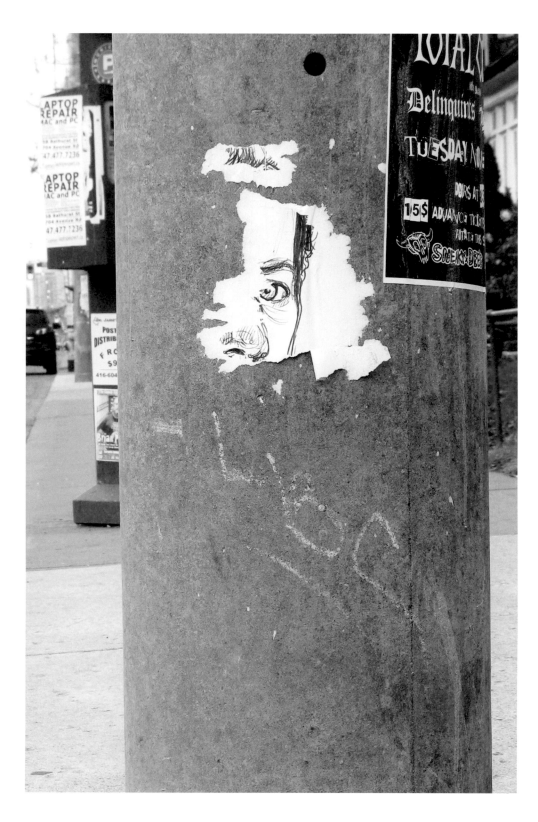

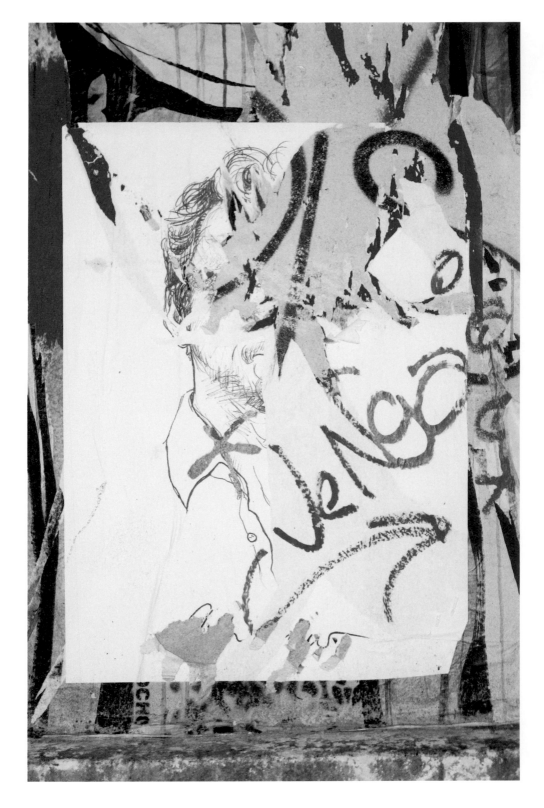

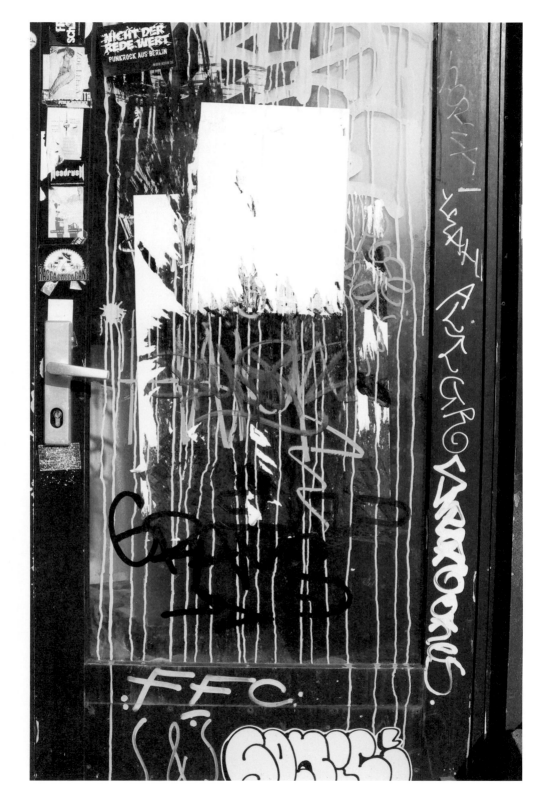

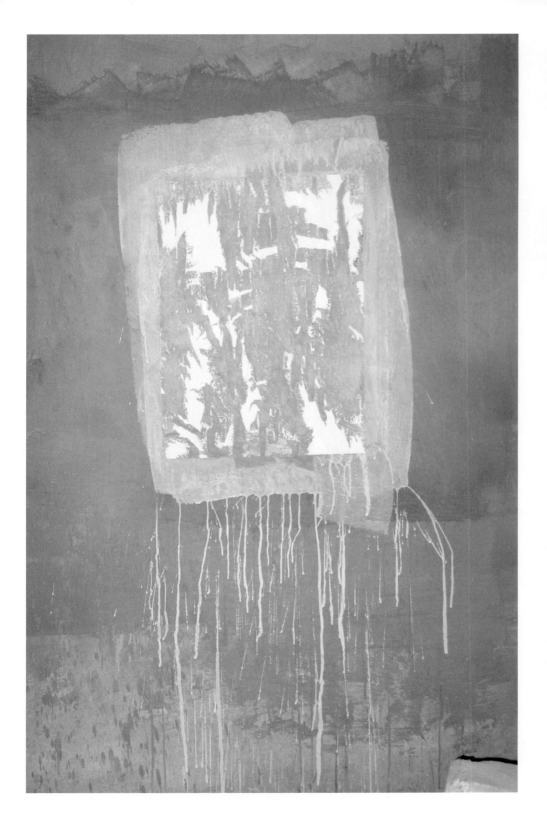

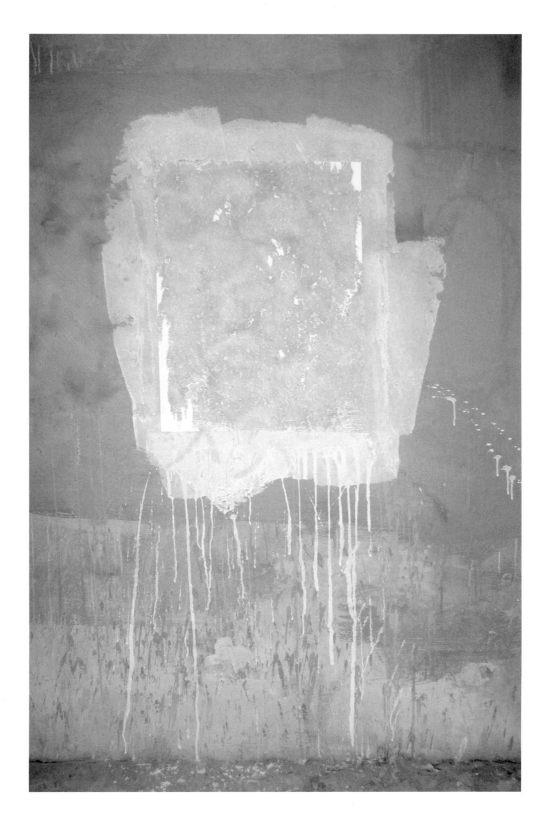

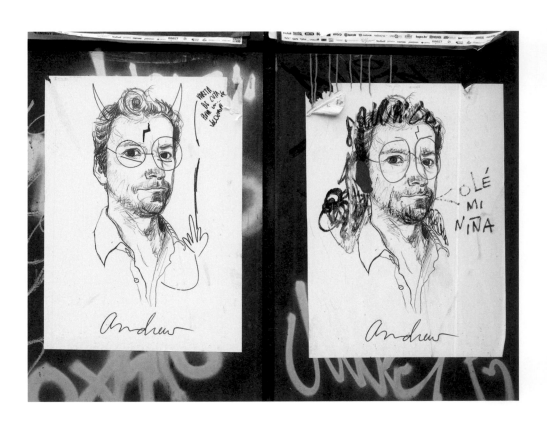

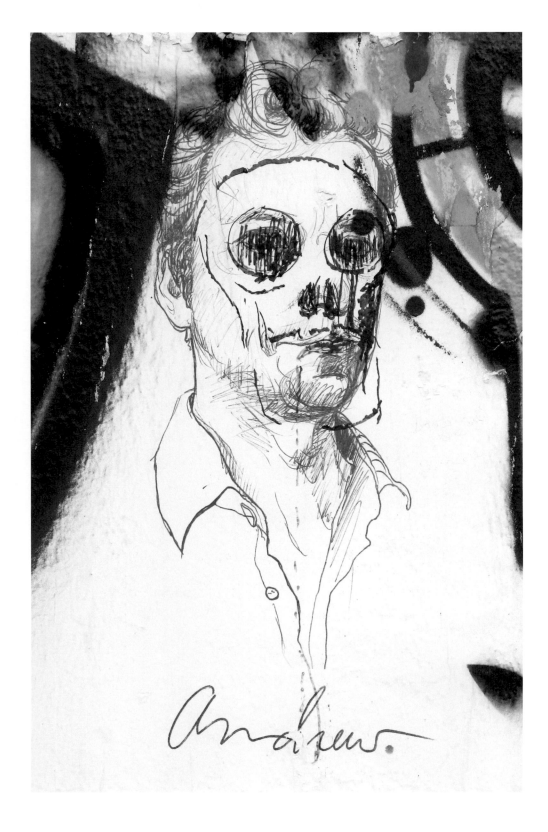

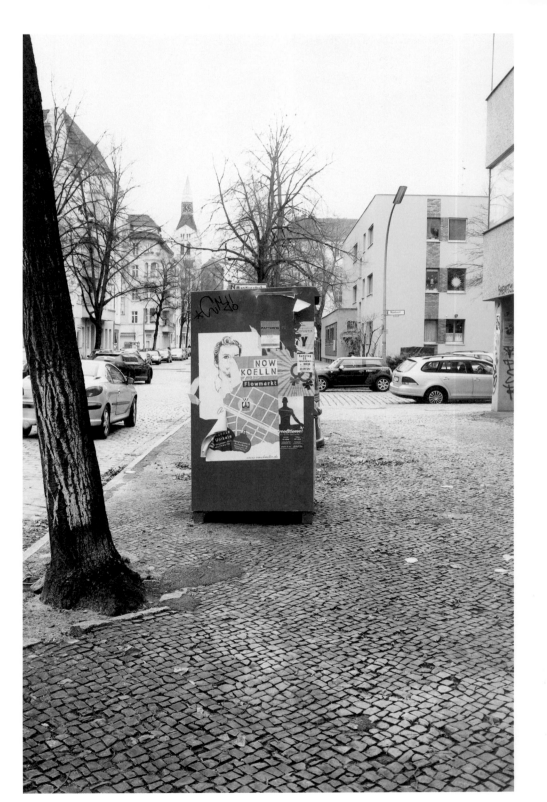

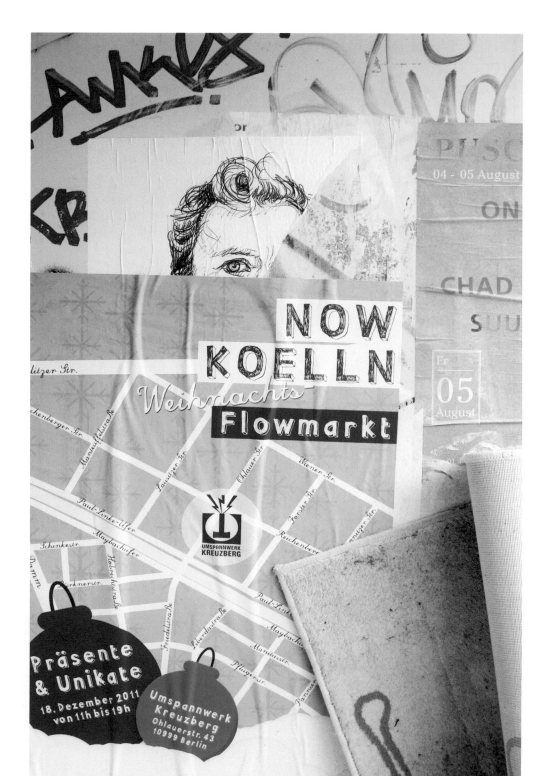

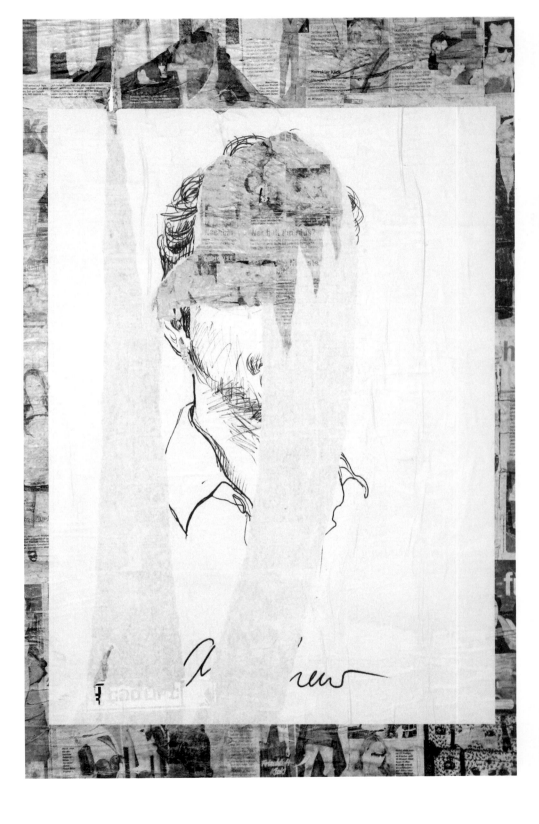

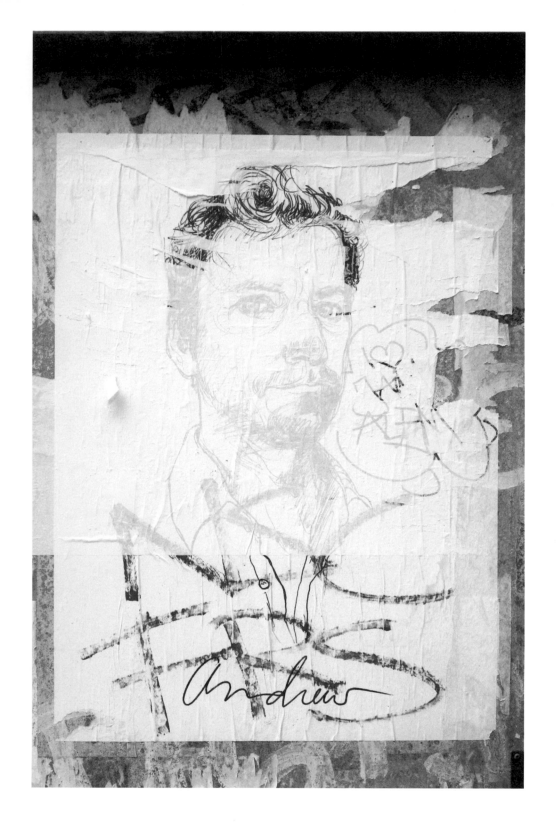

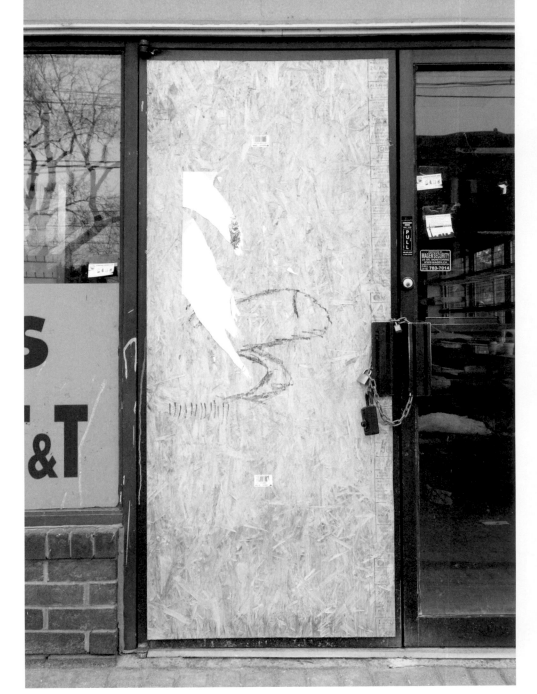

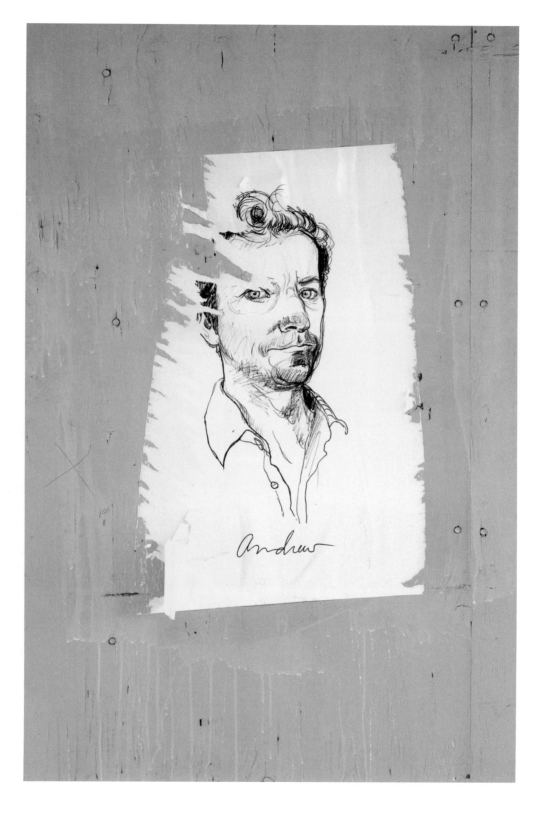

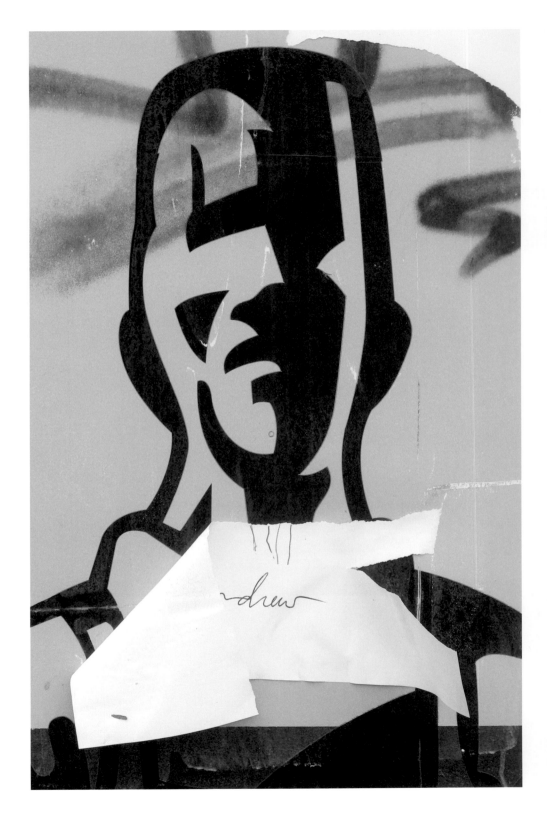

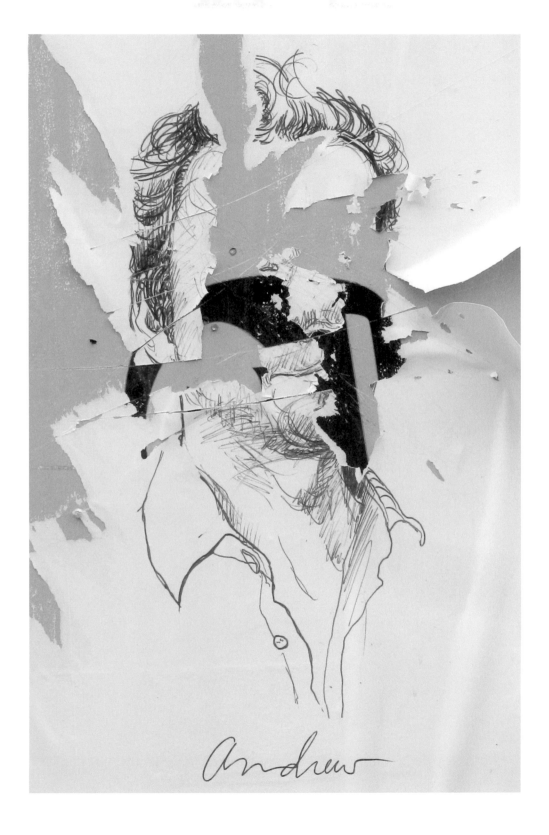

..E, ANIMAL SCREAM..
..NOIZE, ALOE BL..
..Y BEETROOTS..
..ENEMY, BATTLES
..TURE, dEUS
..KIL.. ..HERCULES AND LOVE A..
..DDR & DORFMEISTER, APPARAT..
..HA.. ..SAY.. ..THE NAKED AND FAMOUS..
..ANTHA ..U PRI.. ..A-TRAK, SKRILLEX,..
..URANA S..M SIST.. ..A, MOUNT KIMBI..
.. YUKSEK, BRODINSK.. ..HE BLACK ANGELS..
..BL.. WATERS, RETRO S.. ..TUNE-YARDS, DR..
..ACK, T, ANDY BUTLER.. ..D, GESAFFELSTE..
..F 19..4, JIMMY ED.. ..SPECIAL, BOY..
..NIEL W.. ..REM.. ..DRO..O, ORE..
..RES REL.. .. X..NY MO..
..NGAR ART TRAIL.. ..CO, BERLIN .. RECORDARKE

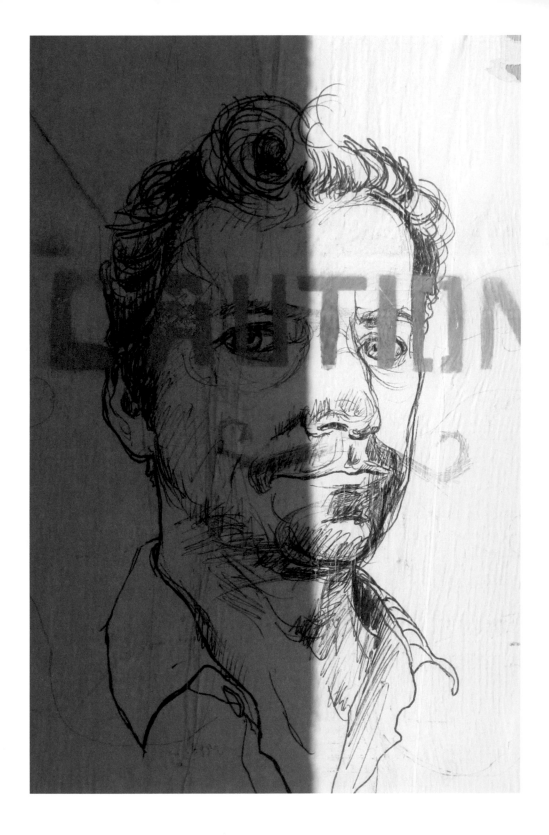

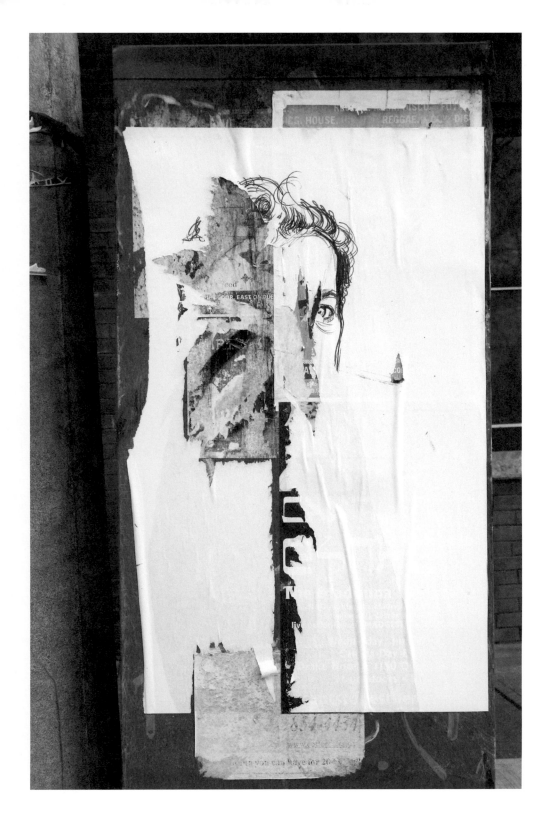

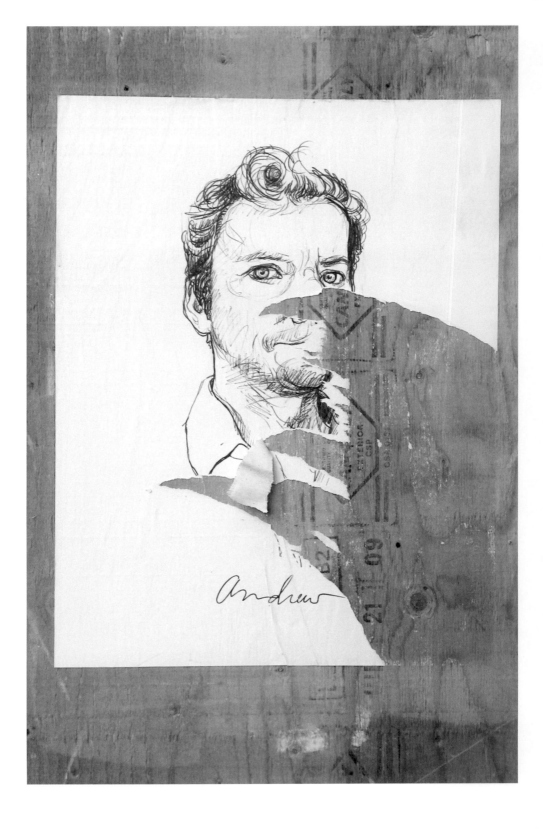

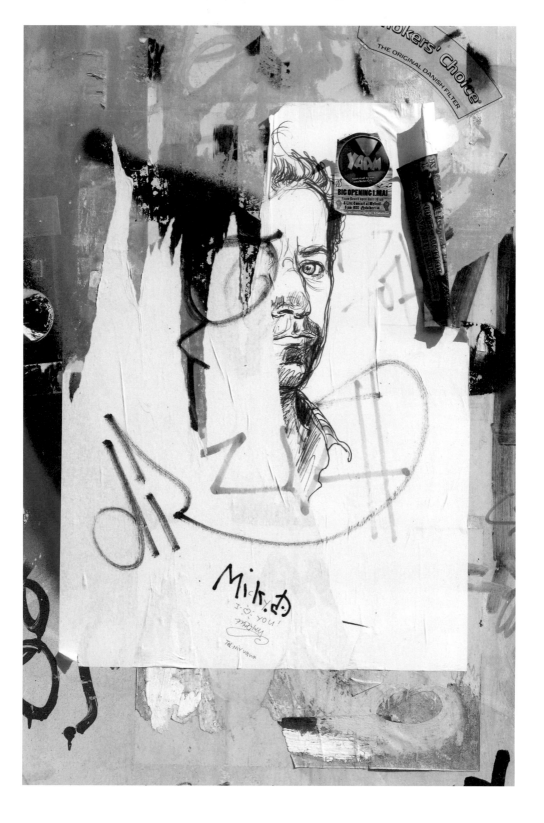

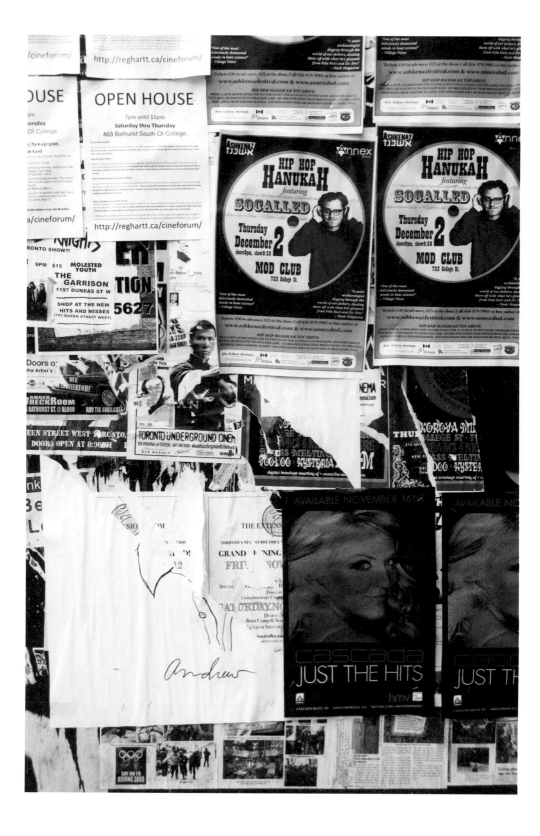

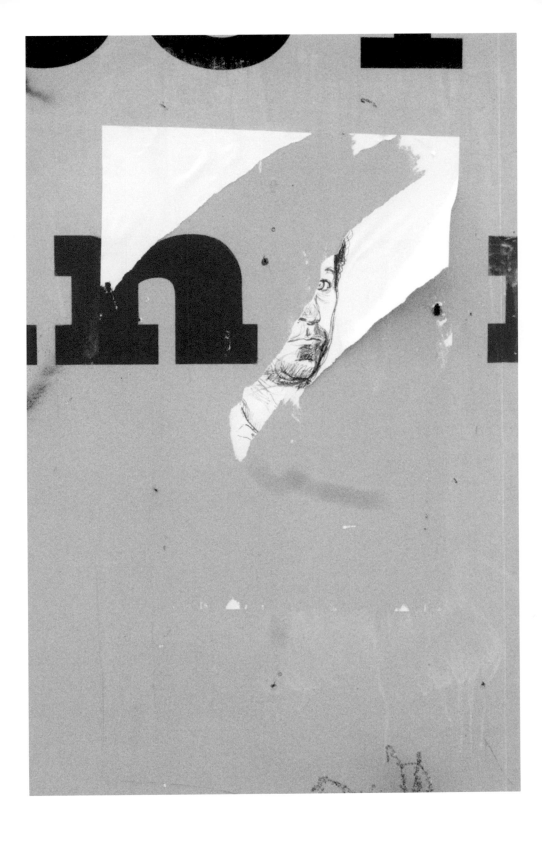

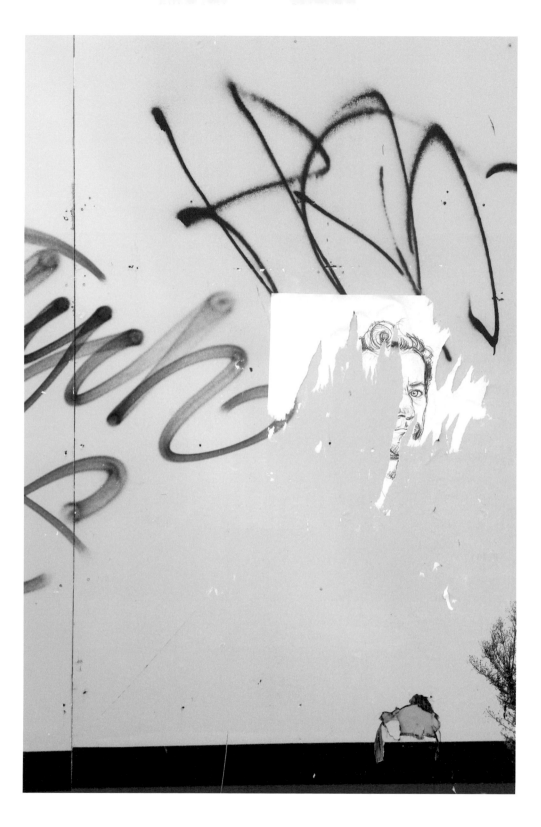

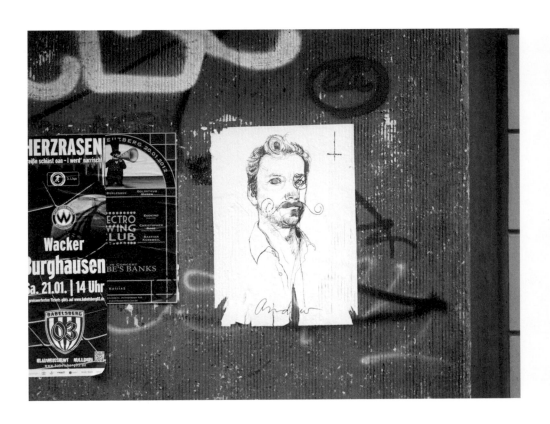

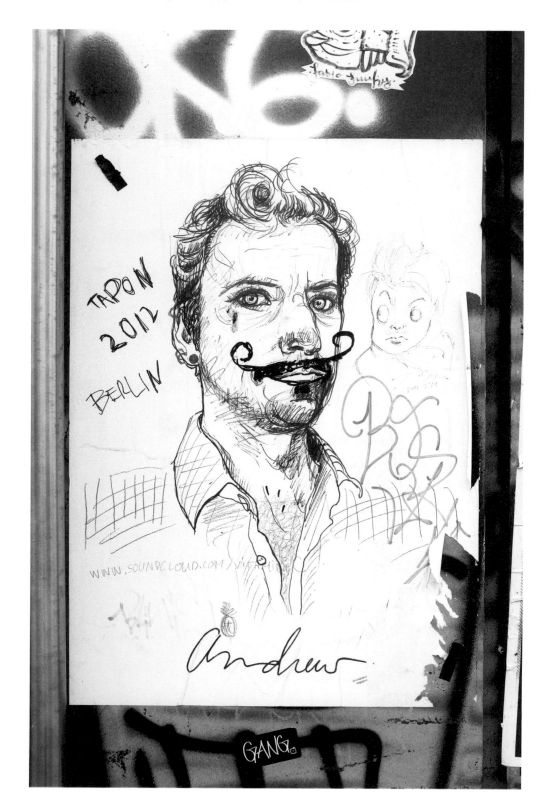

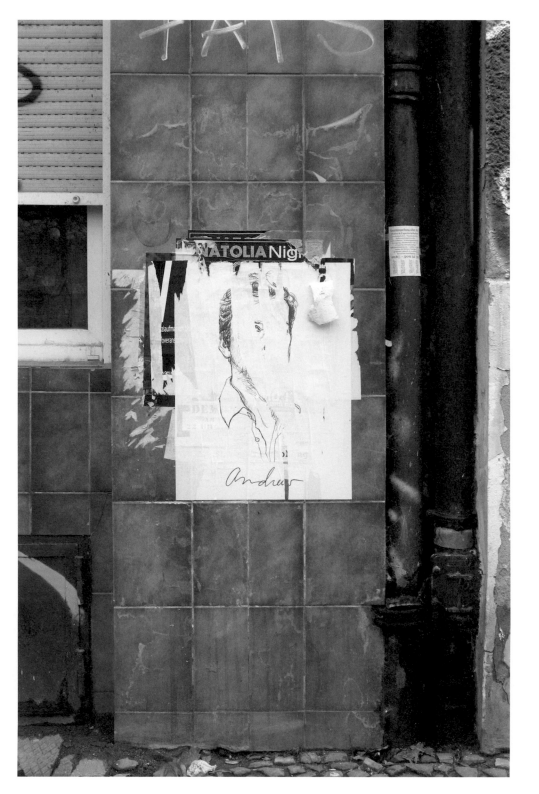

Schönhauser Allee 176 a - U-Bhf Senefelderplatz

FUZZTONES 11 PM
LOVELAND 10 PM

www.fuzztones.net www.lanaloveland.com

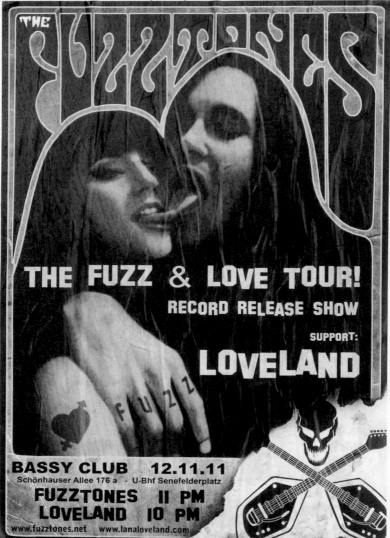

THE FUZZ & LOVE TOUR!
RECORD RELEASE SHOW

SUPPORT:
LOVELAND

BASSY CLUB 12.11.11
Schönhauser Allee 176 a - U-Bhf Senefelderplatz
FUZZTONES 11 PM
LOVELAND 10 PM
www.fuzztones.net www.lanaloveland.com

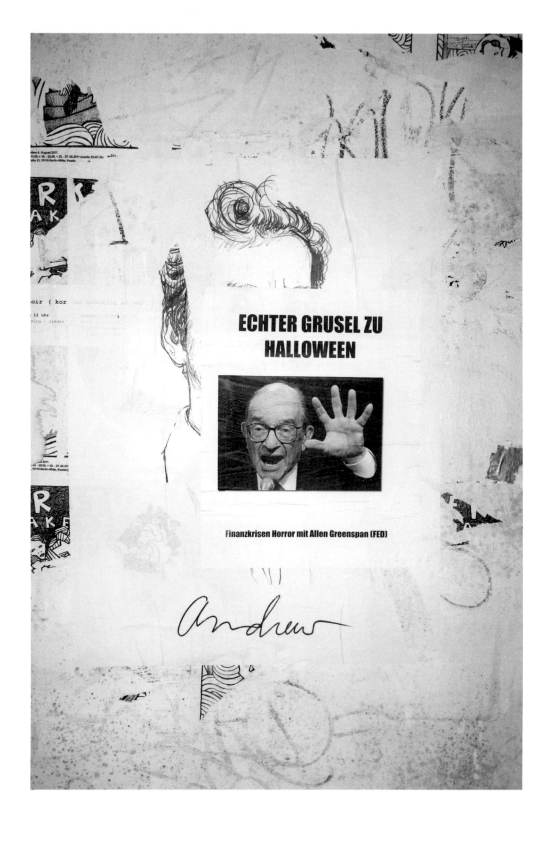

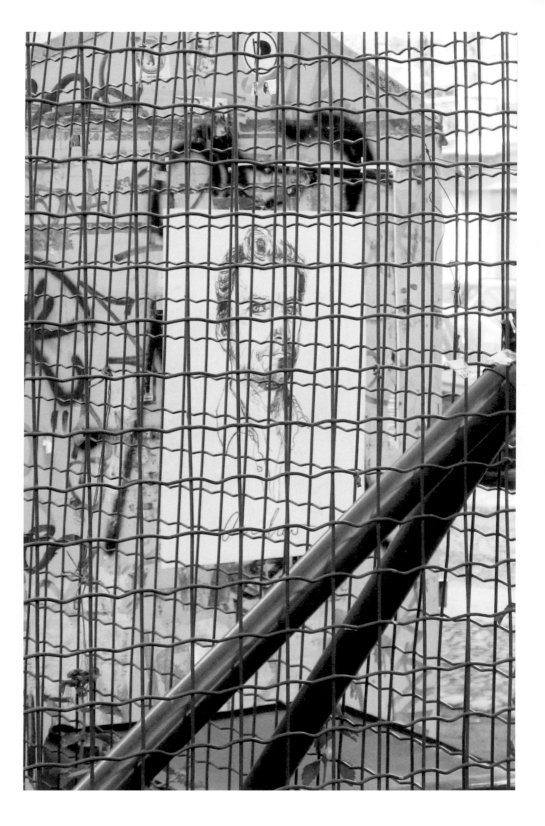

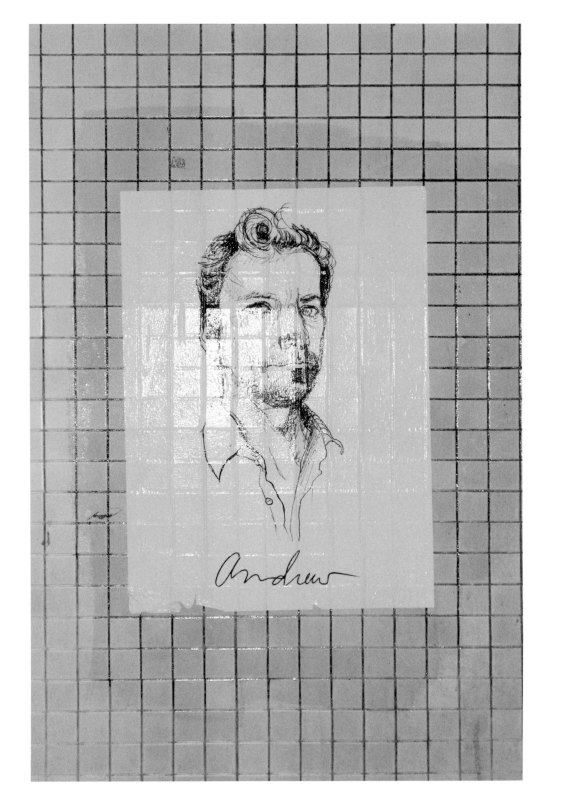

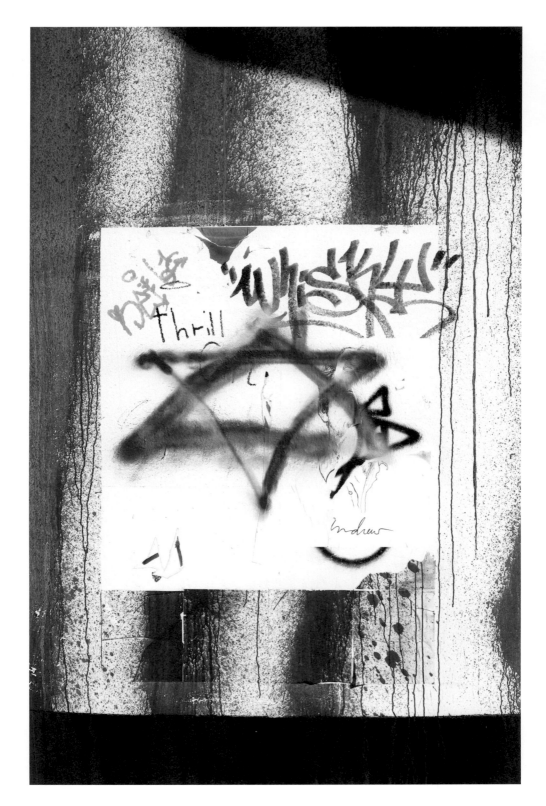

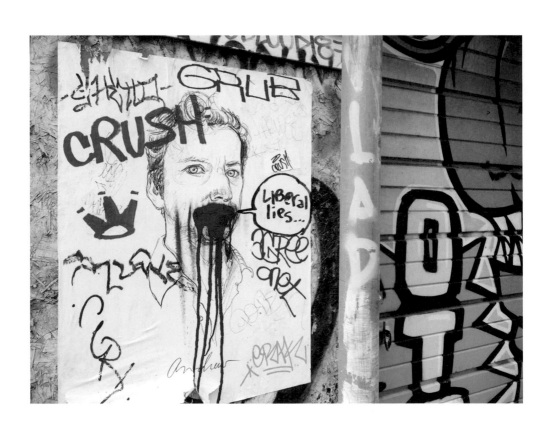

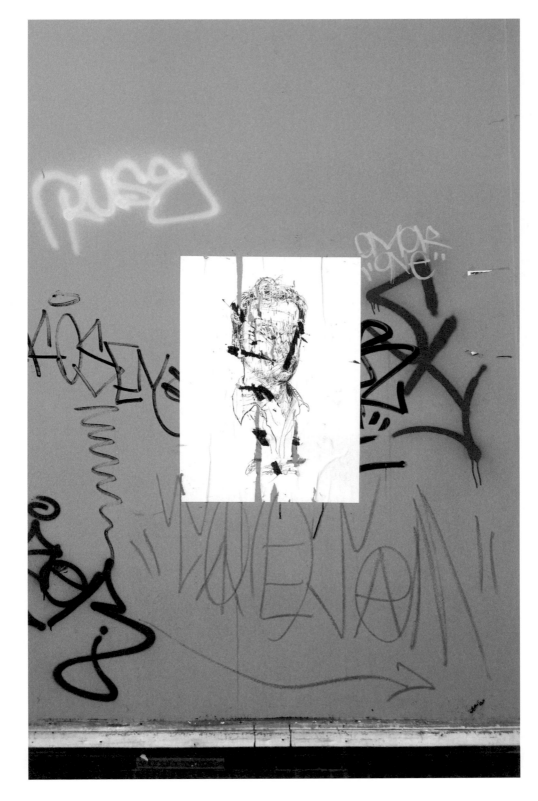

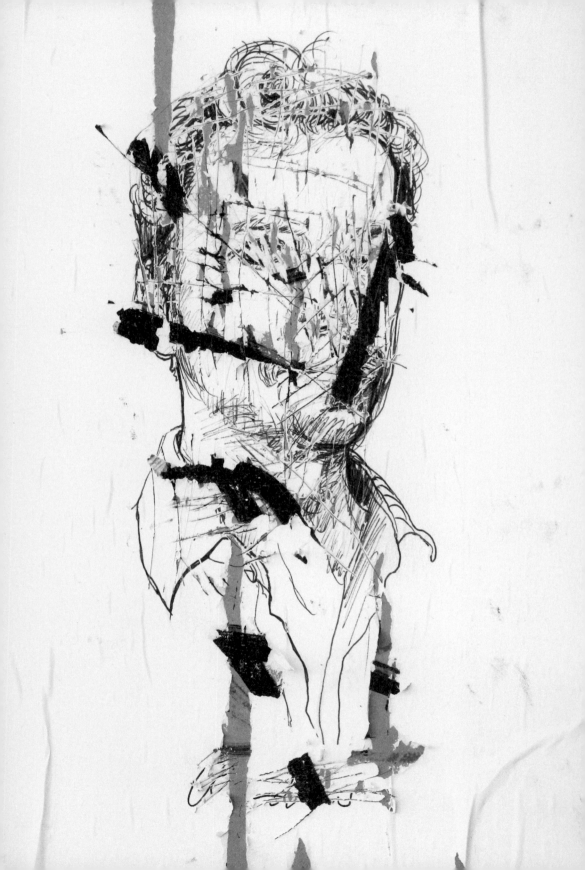

fucking
CANADIAN Terorist
baby Killer

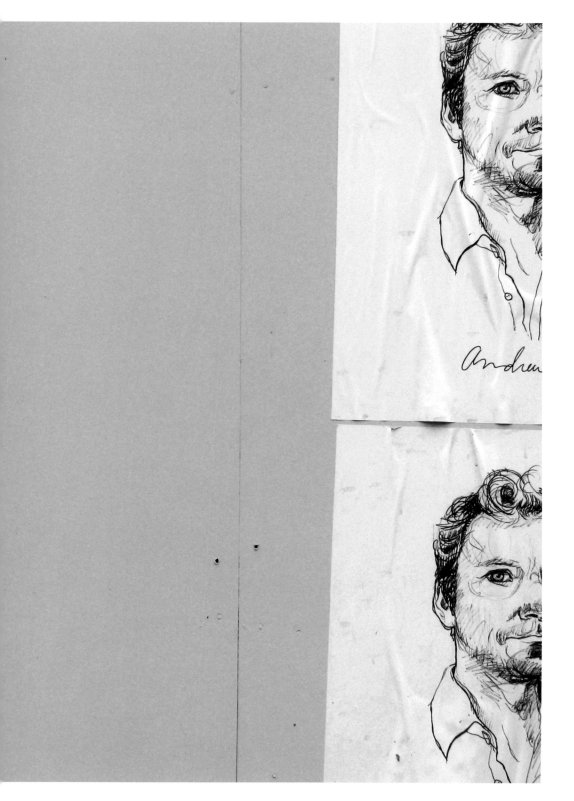

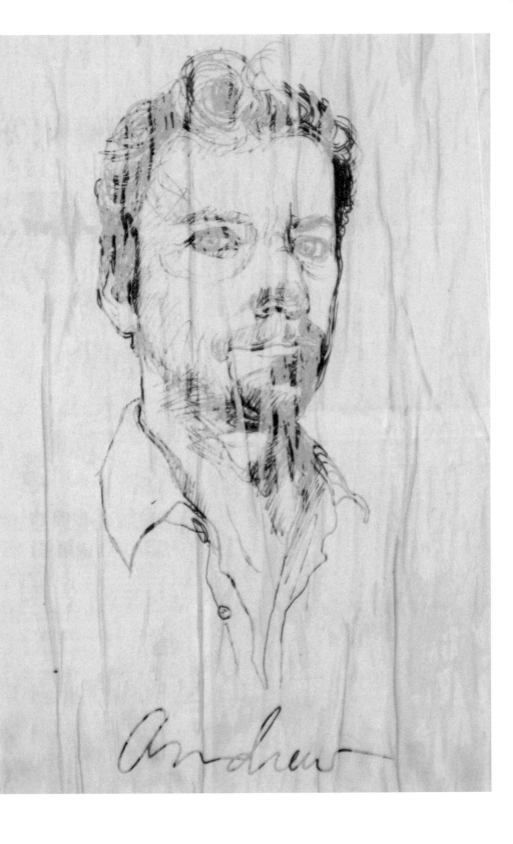

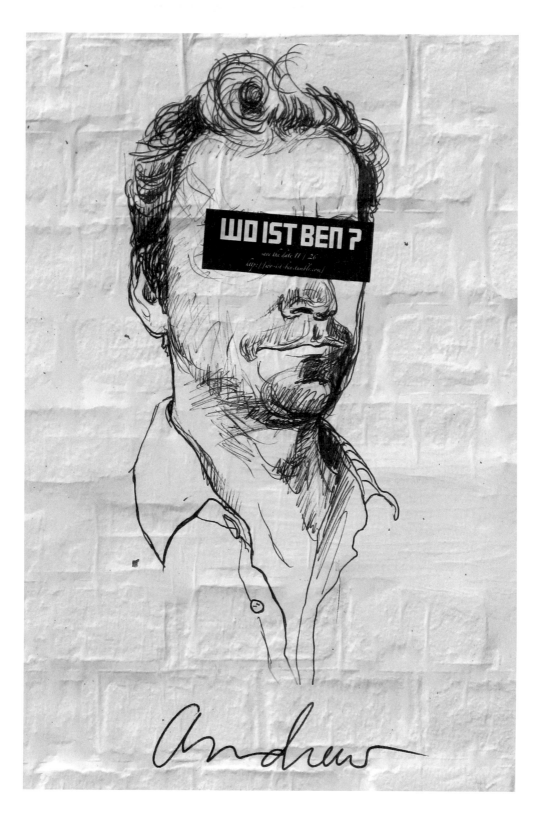

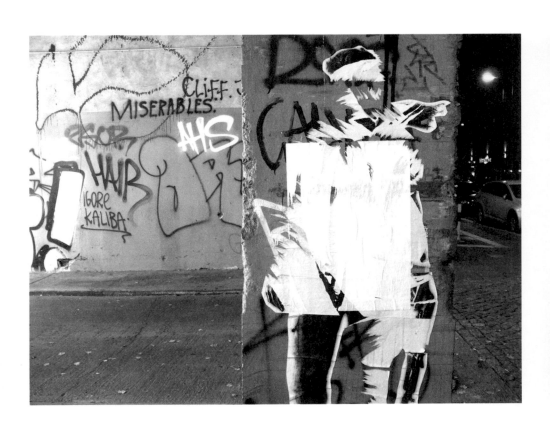

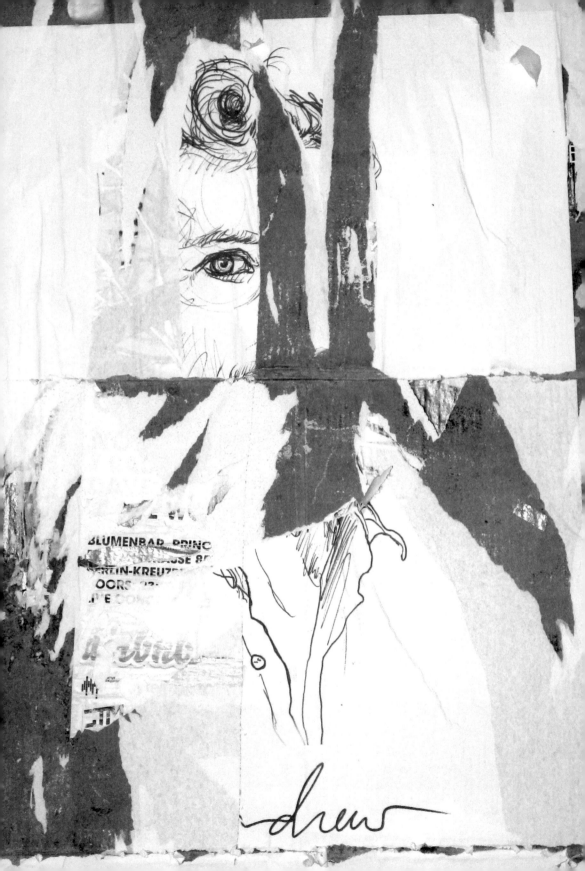

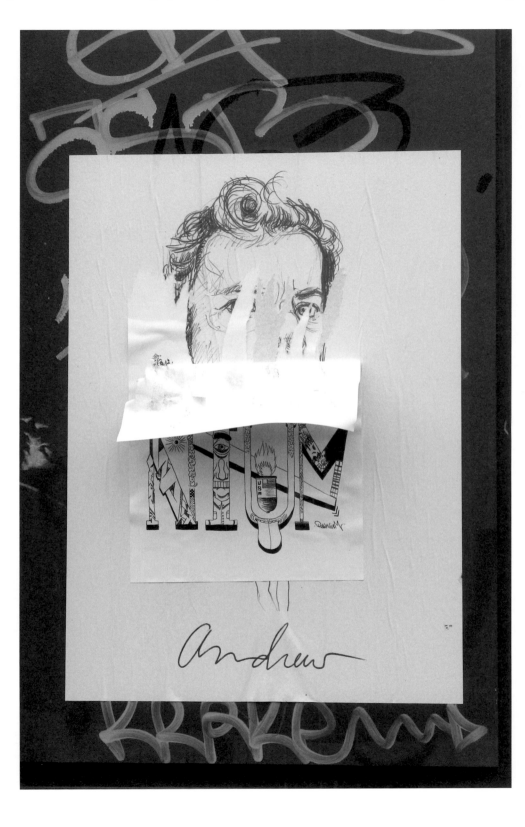

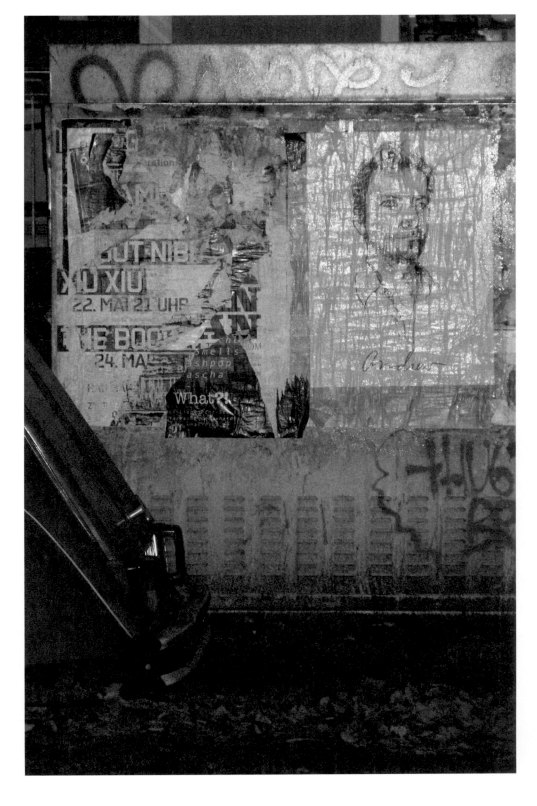

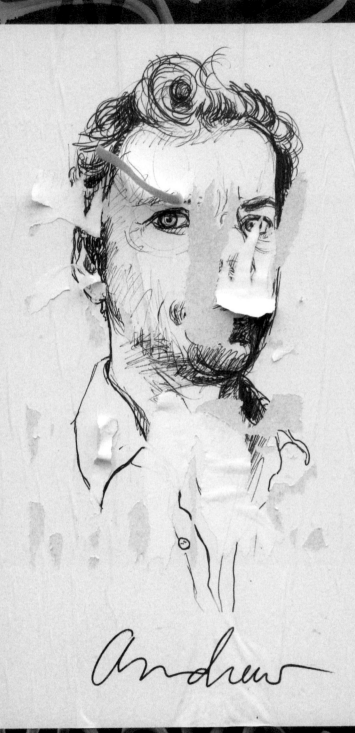

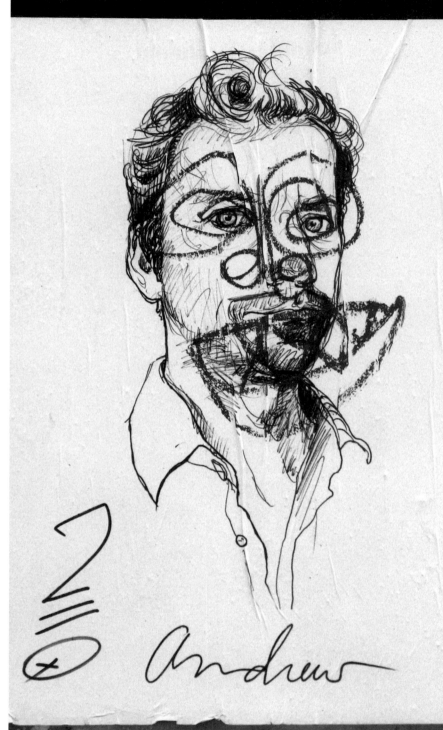

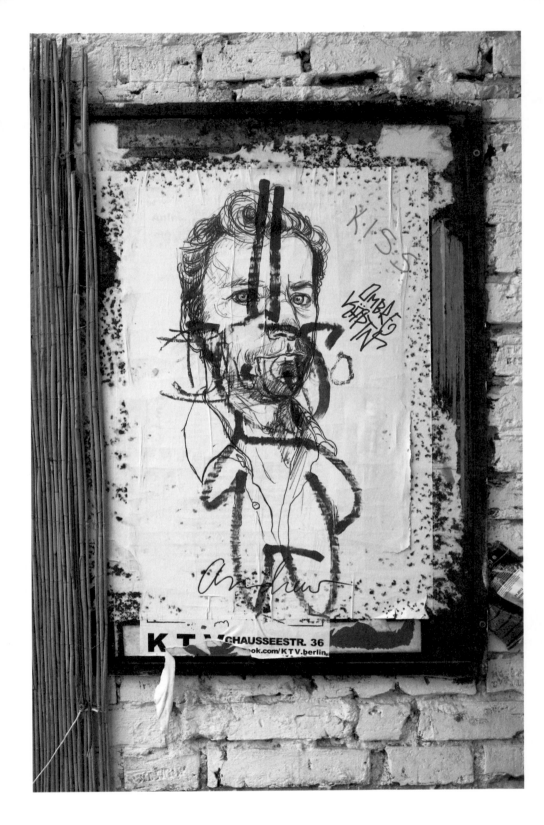

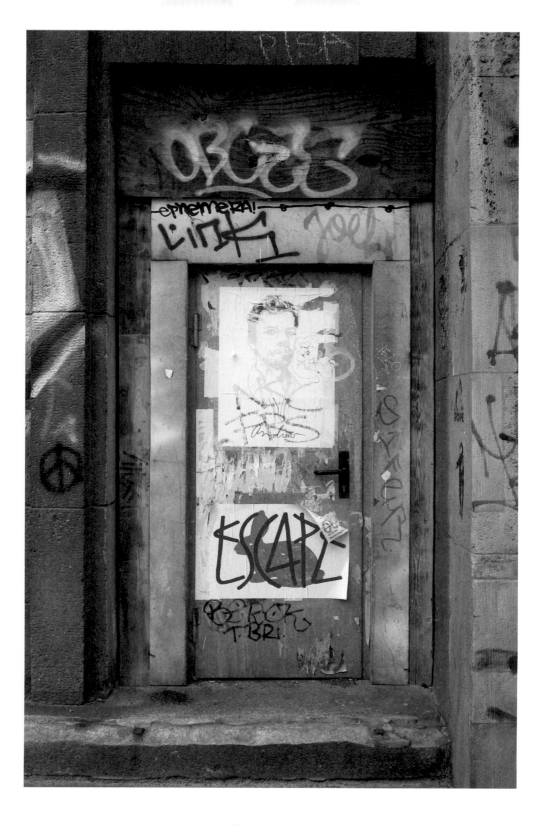

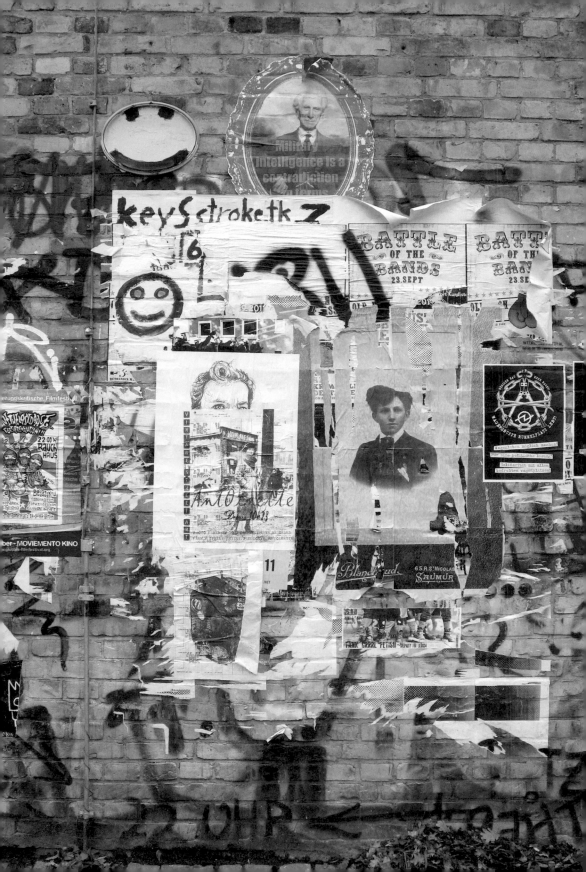

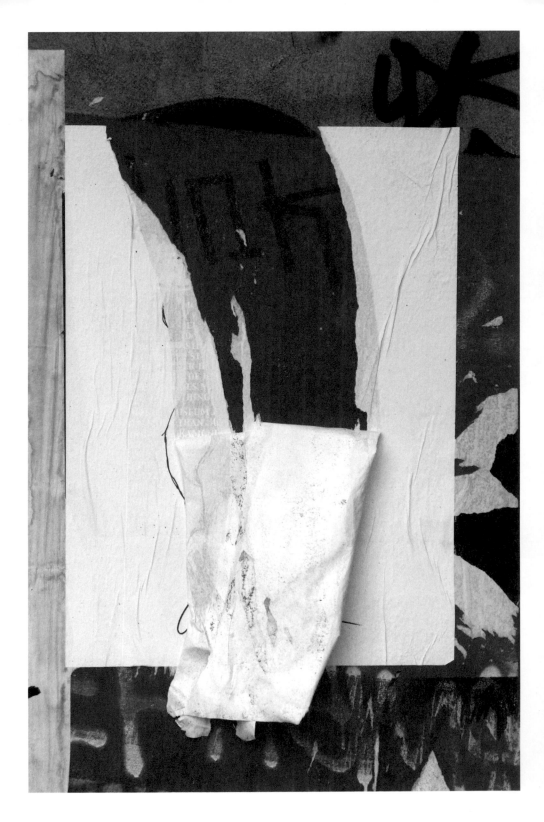

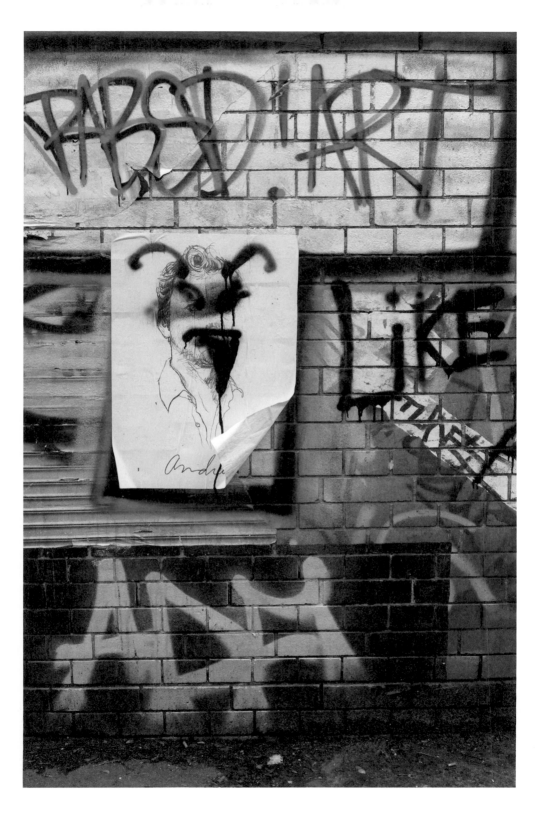

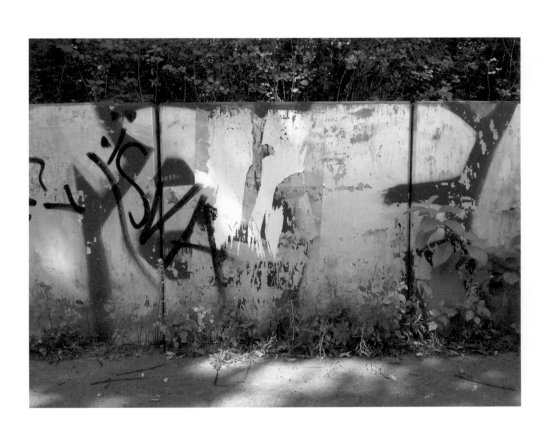

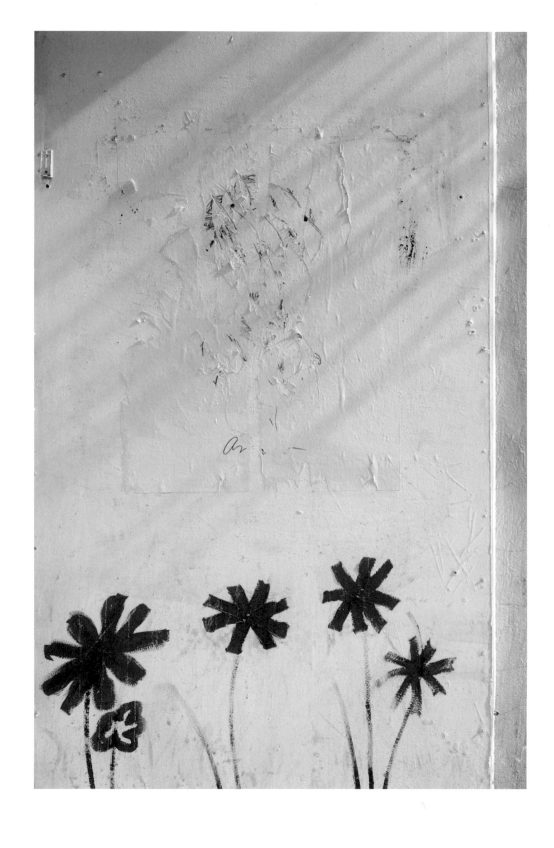

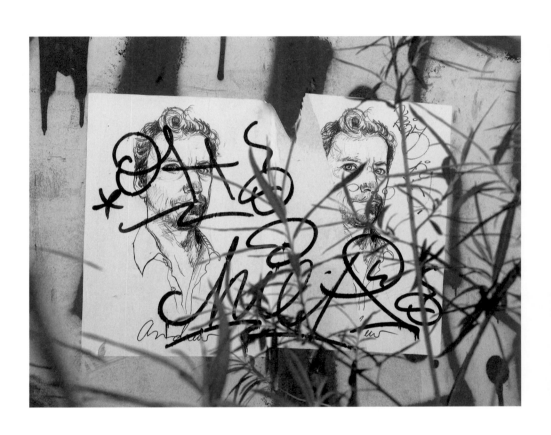

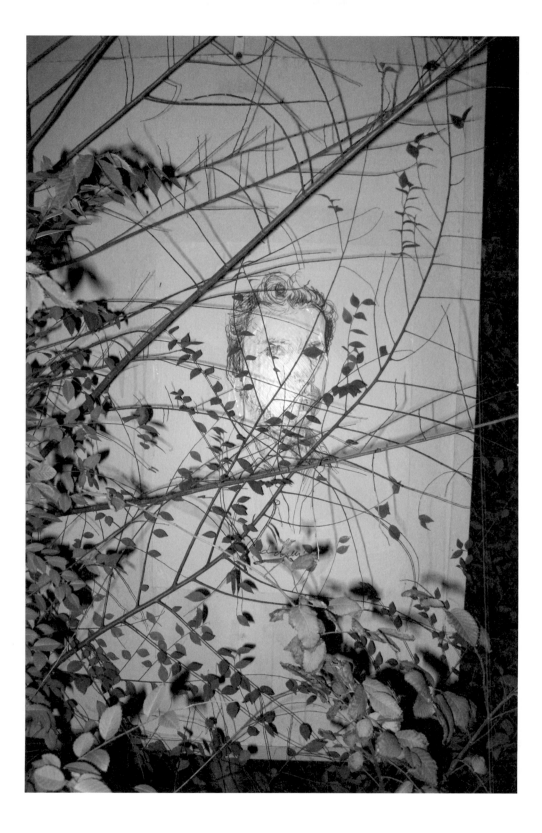

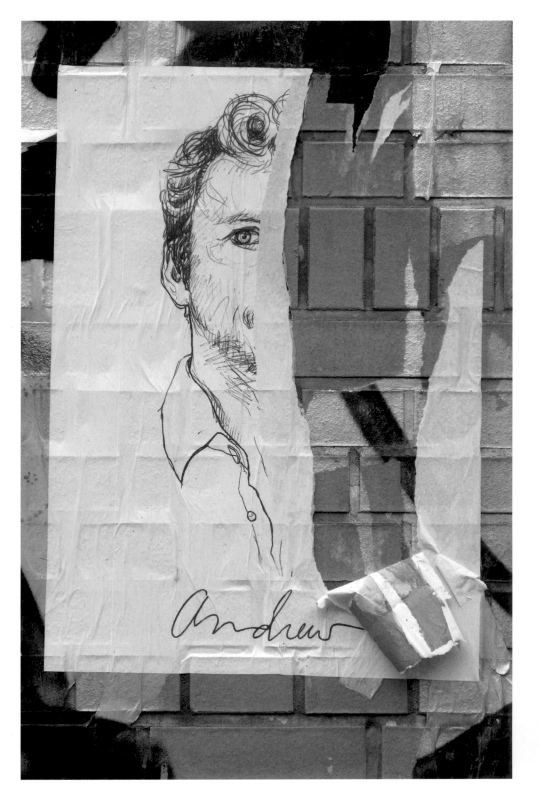

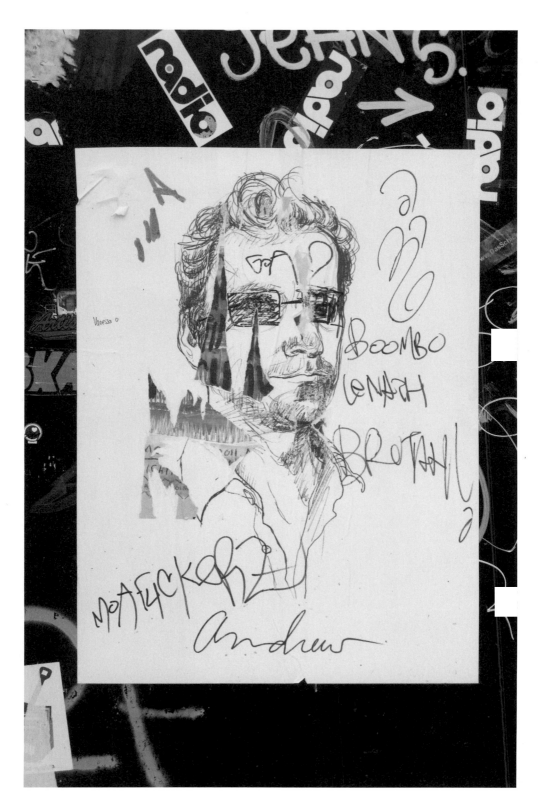

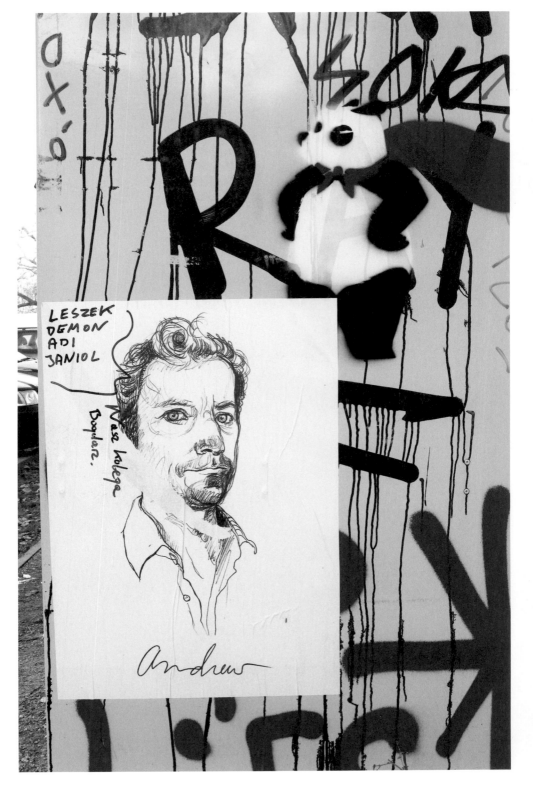

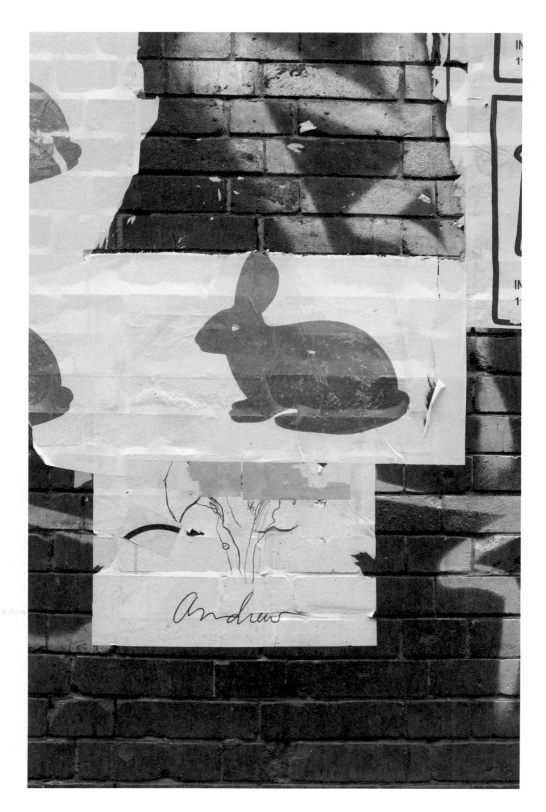

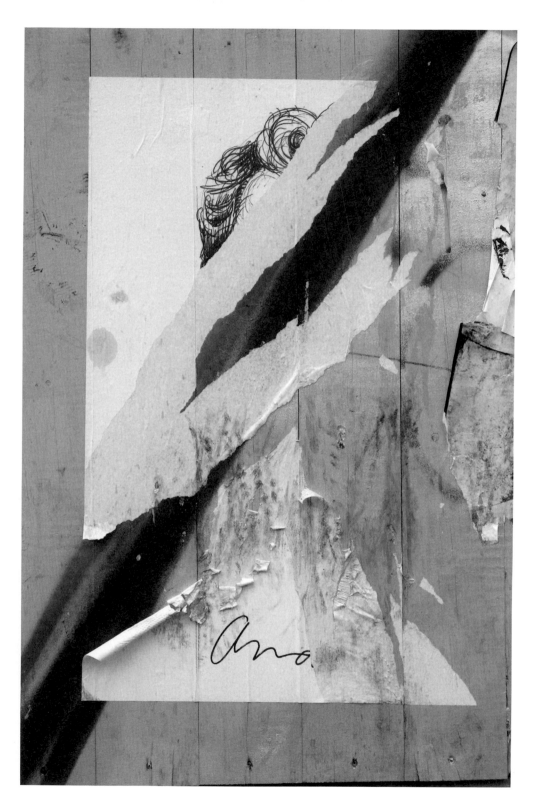

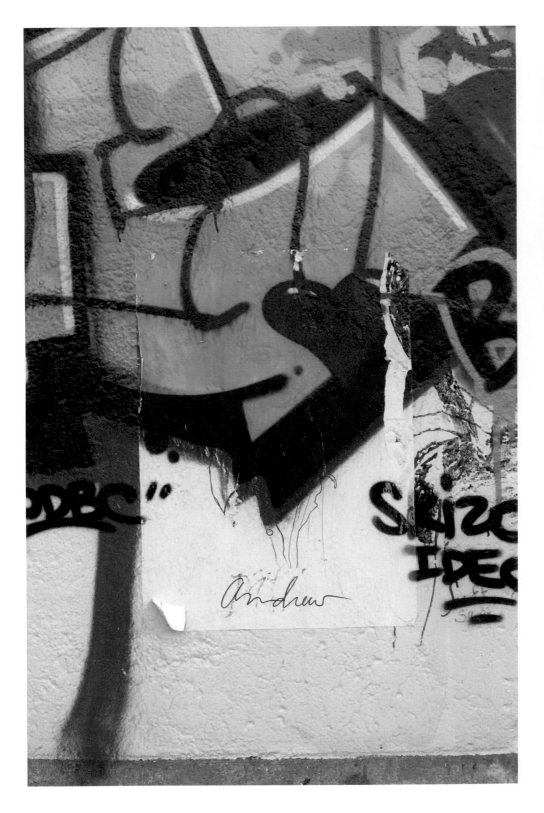

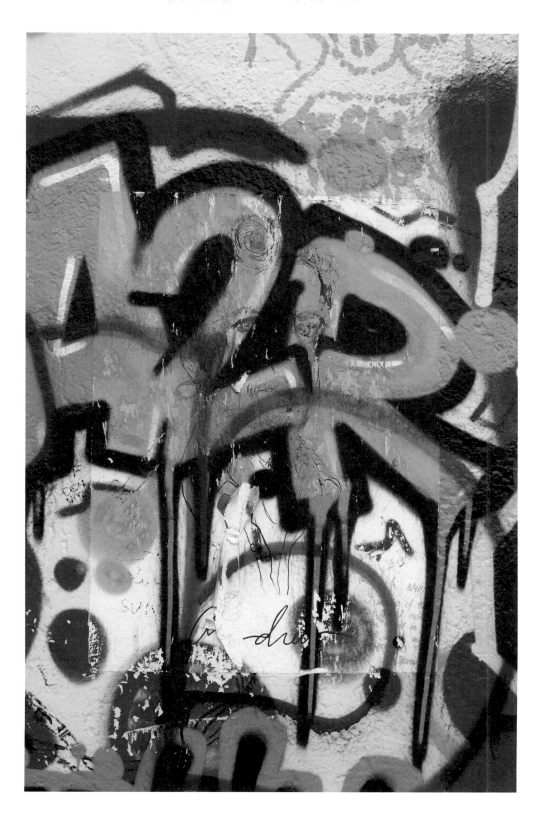

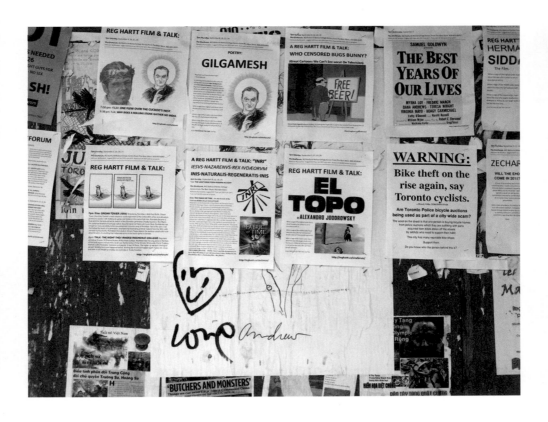

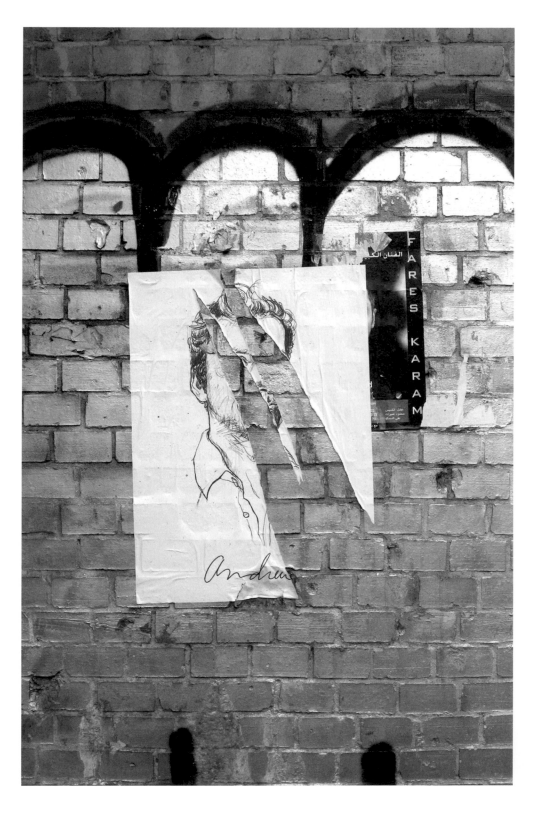

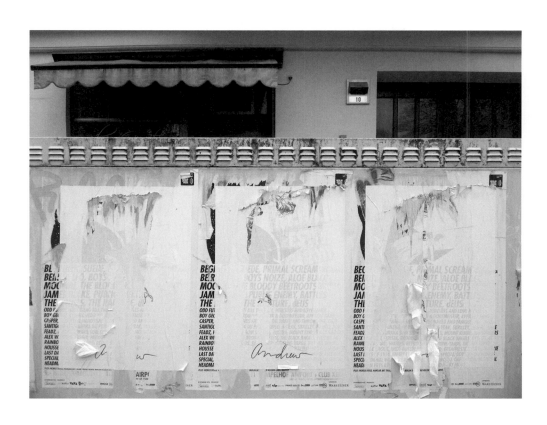

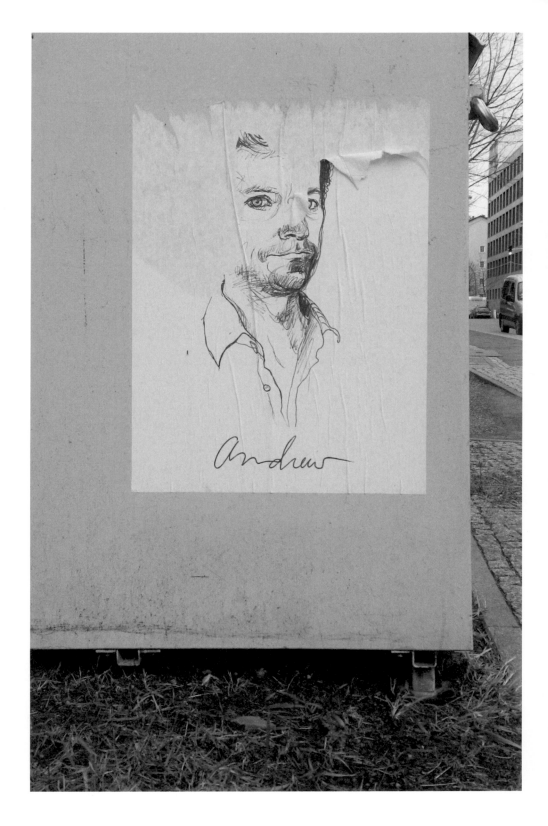

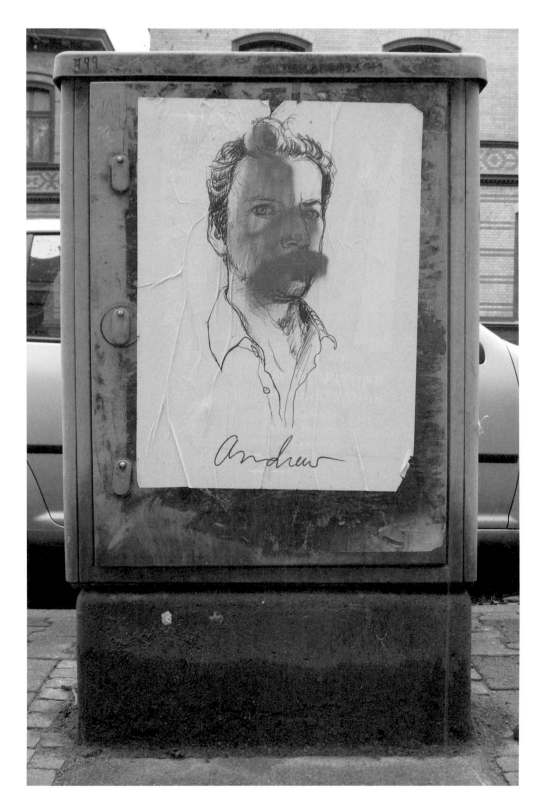

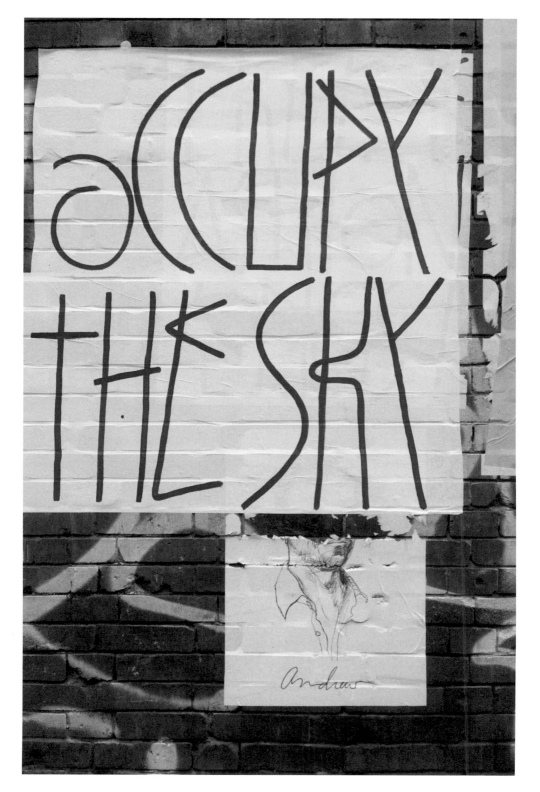

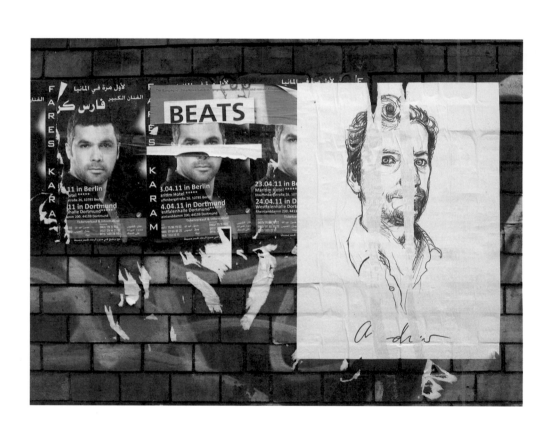

HOHOHO
WEIHNACHTSKATER
MARKT
2011

FRIDAY, DECEMBER 9 & SATURDAY, DECEMBER 10
FROM 13:00 TO 21:00

A.D.DEERTZ · A LOJA · ANNALINA · ANTONIO · AURELIA PAUMELLE
BAERCK · BUTTERFLYSOULFIRE · CHAOS IN FORM · DE LA REH
XVLL DIX–SEPT · GYPSY CHIXXX · HAPPY SHOP · JELLAH
MUSCHIKREUZBERG · POTIPOTI · PROPORTION · REALITYSTUDIO · REPUS
SESSIES–ZEUG · S&YM · SOPOPULAR · SUPERCASH · STARSTYLING · TEMPORARY
SHOWROOM · TIMELESS · AND SO MANY MORE FABULOUS DESIGNERS

DELICIOUSNESS BY
JOSIE'S BAKERY
GLÜHWEIN INFERNO

PERFORMANCE BY
RENATE VON REGENBOGEN
KATE LEIDEHIRN

LIVE
LUST N LOVE
DEON

KATER HOLZIG
MICHAELKIRCHSTR. 22
10179 BERLIN

-held-
VODKA

SUPERCASH

KATER

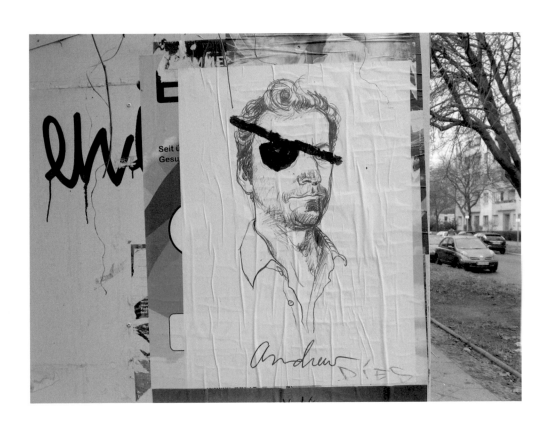

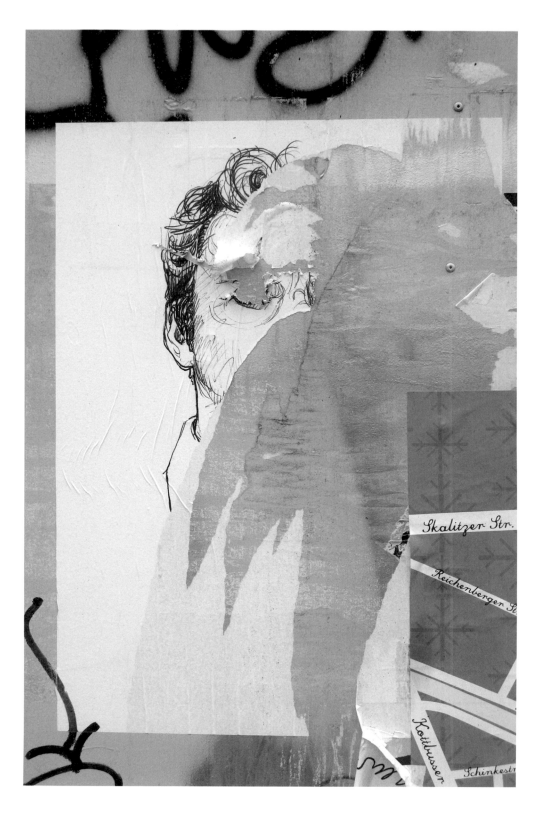

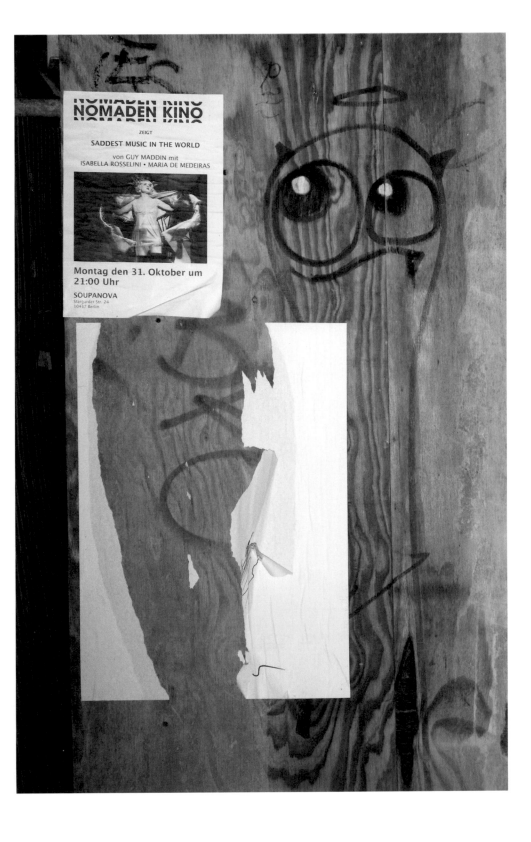

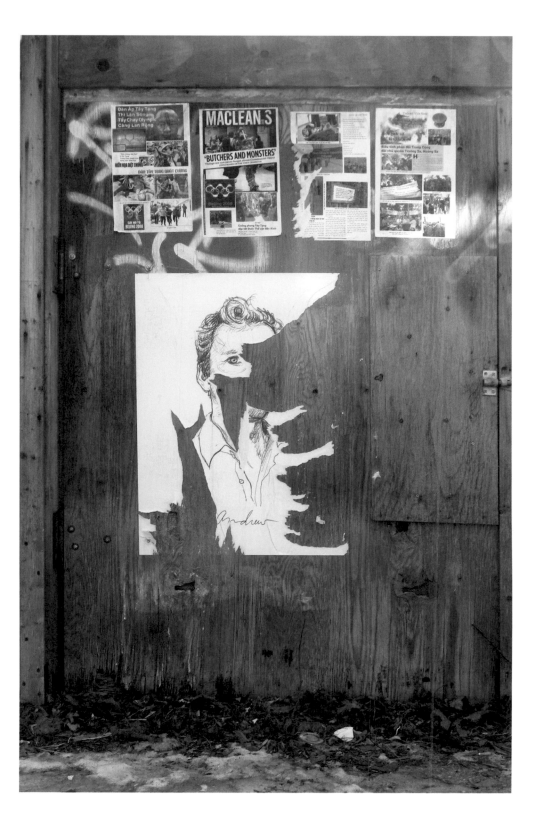

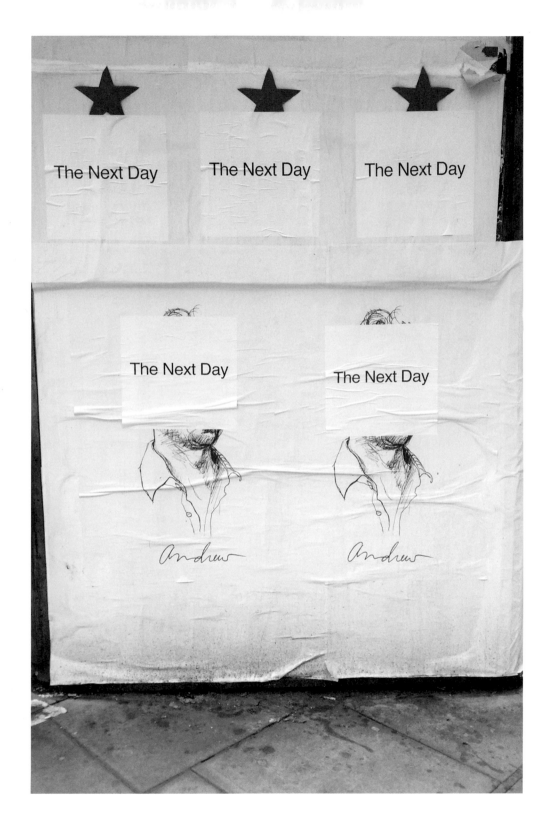

All photographs by Shaan Syed, with the exception of p.26 – Jim Lambie, p.27 & 92 – Barry Patterson, p.100 – Andrea Dettmar, p.111 – Bella Manu, p.169 – Anthony Hunt.

This publication was made possible through the generous support of the following Patrons

Donald Ainslie
Rui Amaral and Daniel Faria
Stephen Andrews
Ted Berezny
Cees Van den Burg
Pixie Black and Steve Webb
Nicholas Brinckman and Tamara Winiarska
Emmett Cawley and Erin Crowe
Dan Donelly
Paul Halferty
Richard W. Ivey
Derek and Anita Keegans
Jeffrey Kofman and Michael Levine
Roy Lamond
Michael MacLennan
Steven Matijcio
John McCoach
Danny McCubbin
Jon Meyer
Morley Nirenberg
Ife Okwudili
Barry Patterson
Howard Podeswa and Joy Walker
Jeremy Podeswa
David Robertson and Peter Ronn
Cherie Spencer
Stephen Suess
Shahla Syed
Susan Tonna

Thank you for advice, getting dirty, putting me up, emailing me photos, contributing to this publication, and working for the love of it

William Anskis, S1 Artspace, Yvonne Bambrick, Robert Birch, Anagram Books, Jamie Bradley, Nicholas Brinckman, Dashiel Brinckman, Bill Clarke, Ruth Claxton, Stuart Cumberland, Tyler Curtis, Ashley Denton, Andrea Dettmar, Atelier Dreibholz, Paulus Dreibholz, David Edwards, FormContent, Corinn Gerber, Stev'nn Hall, The Hull Family, Anthony Hunt, Louise Hutchinson, Galerie Michael Janssen, Andrew Jones, Jeffrey Kofman, Jim Lambie, Scott Leonard, Birch Libralato, Patrizia Libralato, Adeline Mannarini, Bella Manu, Daniel McGhee, Tom McGillis, Janet Mcleod, Art Metropole, Shawn Micallef, Joe Moran, Nicholas Muellner, Hal Niedzviecki, Steven Pacifico, Barry Patterson, Benny Nemerofsky Ramsay, Magali Reus, Glenda Rissman, Alex Robbins, Jane Rolo, David Robertson, Deanne Saunders, Tobias Sirtl, Todd Smith, Ernest John Smith, Stephen Suess, Rehan Syed, Dane Reinacher, Lars Theuerkauff, Geerten Verheus, Pieternel Vermoortel, Tobias Vogt, Vous Etes Ici, Jeanine Woollard, Derek Wagler, Chris Fite-Wassilak, Brent Zavitski.

The Andrew Project (London) was made possible with support from **The Elephant Trust**.

The Andrew Project

Published and distributed by FormContent and S1 Artspace

FormContent | S1 ARTSPACE
SHEFFIELD

Designed by Atelier Dreibholz: Paulus M Dreibholz
and Daniel McGhee

Printed by Holzhausen Druck GmbH, Austria

ISBN 978 0 9560324 1 6

This publication was made possible with the support of
Arts Council England

THE ANDREW PROJECT

1000 and Something Portraits in Toronto, Berlin and London, 2010–2013

With contributions from

William Anskis

Ruth Claxton

Stuart Cumberland

Jeffrey Kofman

Scott Leonard

Nicholas Muellner

Benny Nemerofsky Ramsay

Chris Fite-Wassilak

Jeanine Woollard

SHAAN SYED

Chris Fite-Wassilak

The Ha-ha crystal: Phenomenologies of the Speech Bubble

A three inch tall Alice walks through the leaves and tall blades of grass. She stumbles onto a clearing where the elongated, turquoise figure of the Caterpillar smokes a hookah, dispelling fumes as he sings, 'A–E–I–O–U...' Each letter, perfectly formed in smoke, emerges from his mouth as he makes its sound. Spotting Alice perched listening at the base of his mushroom divan, he stops singing to ask her roundedly, 'Who are you?' An 'O' billows forward, shot through by a small, pink 'R', a whispy 'U' curling underneath as the letters travel from his puckered lips towards the curious girl. In Disney's animated amalgamation of the Lewis Carroll stories *Alice in Wonderland* (1951), the Caterpillar's persnickety exactitude is given a simultaneous visual and aural quality: a literal onomatopoeia where each utterance becomes a corresponding floating phonetic shape.

His uncanny smoke-vowel abilities, though, could be seen as more than just a fancy party trick. His song harks back to the time when we, as nappy-clad infants, begin to connect the sounds we have learned to imitate with the shapes that somehow carry them; or later, when

after learning the alphabet, we begin to access the secret life of written words and their pent-up potential. This primordial moment also carries within it the seed of one of the syntactical hallmarks of comics and graphic novels, the speech bubble. A white horizontal oval that holds words, with an open-ended triangle protruding from its bottom to indicate who uttered them. Its empty shape is a recognisable icon in itself. In French their name, *bulle*, means 'bubble', but also a 'closing off'. In Italian, the body of comics as a whole take their name from this device; *fumetto* translates as 'little puff of smoke'. New Yorker Will Eisner, creator of 1940s comic strip *The Spirit*, in his how-to book *Comics and Sequential Art* (1985) gives a terse account that goes along with this physical take: 'Steam from warm air expelled during conversation can be seen. It is logical to combine that which is heard within that which is seen resulting in a visualised image of the act of speaking.'[1] The English name for the device brings to mind more someone who has eaten soap burping, birthing some sort of large, egg-shaped vessel.

Looking at the speech bubble's silent and telepathic sibling, the thought cloud – which is a troubling topic in itself for another day – art historian David Carrier goes on to point to the speech bubble as an embodiment of René Descartes' pineal gland. For Descartes, that small, pine-cone shaped organ in the centre of our brains was seen as the 'seat of the soul', connecting the eternal mind to the finite machine of the body.[2] Carrier appears to cast the reader as the mind, and the comic's characters

as the body. But maybe more appropriate to the bubble's enunciative power is Georges Batailles' later taking up of the pineal gland, as 'a sexual organ of unheard-of-sensitivity, which would have vibrated, making me let out atrocious screams, the screams of a magnificent but stinking ejaculation.'[3]

The origin of the speech bubble has been traced back to medieval times, with the labelling of names within a painting appearing on a floating scroll, a sort of incidental prop. By the 19th century, these labels had become a fully functioning part of satirical political cartoons – looking on the surface much like the speech bubbles we know today but acting as an inert, passive comment. In a meticulous essay, 'Of Labels, Loops, and Bubbles,' comics historian Thierry Smolderen connects their invention with the changing habits in reading and listening brought about by the development of first the iron printing press, then the gramophone. The improved printing press could cover larger areas with print, enabling posters and signs to carry variations in written words that could convey the sense of emphasis and tone of the spoken word. With Thomas Edison's gramophone, the voice could come to be conceived as something that could be captured and emitted separate from the body, a 'sound picture'.[4] Only then was the modern speech bubble realised, where characters within a comic were understood to be giving rise to their own speech and holding active, ongoing conversations.

•

One morning in October 1966, residents of Strasbourg awoke to find some of their city walls had been turned into comics. Posters bore the enlarged four pages of University of Strasbourg student André Bertrand's pamphlet *The Return of the Durutti Column*, a short anarchic diatribe that carried some broad Marxist critiques, alongside dialogue taken from a 1960 novel *All the King's Horses* by Michèle Bernstein, then wife of Guy Debord. The first image on the opening page is black, with four speech bubbles punctuating the darkness. Newly elected as the head of the university's student union on the platform of destroying it from within, in the frame Bertrand and his cohorts restage their arguments of whether to run or not:

'If it was going to be fun, yeah, but surely we're gonna get bored among these syndicated scumbags!'

'What if we storm the AGM?'

'Seriously though, we should at least go to Abraham Mole's lectures!'

'Anyhow we haven't got student union cards.'

But they remain faceless; who is speaking is irrelevant, more important is foregrounding the act of speaking. The remainder of Bertrand's comic followed (and through its off-cited, unexpected success, came to exemplify) the Situationist's house style of imposing speech bubbles on top of other people – images culled from the Louvre to *Paris Match*, forcing models and film stars to speak in leftist slogans and dense theoretical doublespeak. Prying the bubble away from the page, out of one story and onto another, the speech

bubble for them was an agent of graffiti, a visible sign in itself, and the medium through which an image's narrative could be détourned. In common usage, the bubble is unnoticed and ignored, despite its bloated, obstructing presence. It's possible these linguistic balloons do exist, hanging in the air of the world of the comic, its oddity an evolutionary fact taken for granted as people converse as if in a scene from a helium capsule exchange fair. But in ascribing a terrain with rules roughly like our own to that within the comic, I believe it is an extra-diegetic physical word sack: we can see it, and can't see whatever's behind it; for the characters wthin the story, we assume it's the opposite. Its contents are the important part, the focus of our attention, and we invest enough in the world created in the story to trust that there isn't just a blank void in the spot made invisible.

In a sharp throw-away comment made in *The System of Comics*, semiologist Thierry Groensteen notes, 'the balloon could also be seen as a hole, a cavity in which we rediscover the printed page, located 'under' the plane of the image.'[5] There is an almost Brechtian theatricality to the honest materiality of the thing. The very body of the bubble is paper, the body of the page itself, each speech bubble a potential reminder of what we're staring at. And there is a blatantly theatrical act of simplification going on as well: scenes from our everyday lives include an infinite number of intervening sounds, halted statements, overlapping words and background noise that create a complex sonic environment;

within the comic frame all this is represented simply by a clearly-phrased speech bubble and a small 'Boink!' The whole thing begs for disbelief. Yet somewhere, hovering between the author and the narrator of the comic is a cloaked figure, some hidden Wizard of Oz behind a curtain who presents the spectacle of the linguistic miracle. What the Situationists and their admirers began to exploit was this shadowy authority – the delivery of specific sounds permitted to be passed over in this container. As an impossibility in both our own and the comic's world, the speech bubble doesn't exist except for on and off the page. As such, it is an independent entity, and one, the Situationists seemed to suggest, that has unique political advantage.

Where Debord et al. were happy scribbling on walls and over *Liberty Leading the People* (1830), they simply replaced one domineering narrator with another of their own devising. Since then, the potential of the free-floating speech bubble, as a physically unstable icon that both denotes speech and creates space for it, has been prodded and turned, let roam, reigned back in, re-branded, and let back out on a short leash. The silent twin of the Strasbourg intervention is Andy Warhol's *Shining Clouds* collaboration with Bell Laboratories engineer Billy Kulver, birthed the same year, filling a gallery room filled with shining, helium-filled mylar pillows. Eventually, the reflective, reticent pillows find offspring as Philippe Parreno's endlessly deployed *Speech Bubbles* (1997). It seems a curious technological and typological twist of

fate that the speech bubble has become tied to the text message: currently, the most rigorous explorations of the bubble are exercised as mobile phone advertisements.

•

After being penned in, deceived, and diverted by any number of glass walls and waiting rooms, Monsieur Hulot is on his way home in Paris when he is waved down by a small man across the street, 'Remember me – the army!' After mumbling pleasantries, the man ushers him into his 'ultramodern' home; and once his front door shuts behind them, we no longer hear their conversation. The camera pans right to reveal the defining feature of the building: floor to ceiling street-facing windows, each small, square apartment a moving tableau that can be watched from the street as we see them remove their coats and hats and enter into the sitting room next door. Hulot meets the wife and daughter, and gets a cursory tour – the man walking towards us and gesturing expansively at his transparent wall – while all we can hear is passing cars and the occasional pedestrian. They turn on the television, and we get a glimpse of the grid of all four windows in the two-story building, each flickering with the light of the same game show or sitcom.

In the nineteen shots and seven and a half minutes of the apartment scene in *Playtime* (1967), Jacques Tati plays on the barriers between the audience and the residents, as well as between the residents themselves.

Two adjacent apartments watch TV on either side of the same wall, and as one takes a large slug of Scotch and the other begins to undress, the opposite neighbour appears to balk and fidget in response. The dislocation of sound from the domestic pantomime only seems to draw them closer, the distances between viewers, ourselves included, turning into a tantalizing proximity as Tati dances around the conventions of the 4th wall. It is perhaps one of the trademarks of postmodernist art to consciously reference, cross and violate the invisible partition between audience and artwork, to highlight what we willingly ignore, but Tati makes light work of it, foregrounding its architectural qualities by making it literally a wall that separates us. To the not-so-innocent bystander, this honeycomb of identical flats, each room a small, framed stage that we look over and back begins to resemble the architectural framework of a page of comics, the camera's movements not unlike our own looks across the page – reading some of one line, skipping across to an image on the other page before doubling back again to step back and take it all in. The comic is a frozen, crystalline architecture, shut behind one of Tati's sound-proof *silence d'or* doors; but from the comic building, the speech bubble punctuates that silence, piercing and straddling the wall that separates the comic world and our own.

As such, the bubble seems to sit in an odd place within a sort of narratological physics. The comic is a structure where durational events are arranged spatially, to become a fragmentally

linear narrative where sound is also solidified into visible form. In the speech bubble is a crossover of surface area and aural effects, an embodiment of ephemeral verbal acts. It might seem silly to say 'out loud', but we could view it as a shorthand, colloquial example of spacetime – that somehow here from the plane of the 2nd dimension comes a suggestion of the 4th dimension. The crystallized sound of the speech bubble, its containment of both a devolved and hidden life of the spoken word, seems to provide one possible response to Robert Smithson's open-ended question on how to visualize the next dimension: '(R. Buckminster) Fuller was told by certain scientists that the fourth dimension was 'ha-ha', in other words, that it is laughter... Laughter is in a sense a kind of entropic 'verbalisation.' How could artists translate this verbal entropy, that is 'ha-ha', into solid models?'[6] Of course, the speech bubble isn't solid other than as a flattened, rounded scrap of wood pulp. But like some worn down sign creaking alone in the winds of a desert plain, it punctures the plane as an unnoticed signpost to some where or time, both within and beyond our own.

1 Will Eisner, *Comics and Sequential Art*, (Tamarac, FL: Poorhouse Press, 1985), p.26.

2 David Carrier, *The Aesthetics of Comics* (University Park, PA: Pennsylvania University Press, 2000), p.30.

3 Georges Bataille, 'The Jesuve,' in *Visions of Excess* (Manchester: Manchester University Press, 1985), p.77.

4 Thierry Smolderen, 'Of Labels, Loops, and Bubbles,' in *Comic Art*, 8 (2006), p.104.

5 Thierry Groensteen, *The System of Comics* (Jackson, MS: University of Mississippi Press, 2007), p.71.

6 Robert Smithson, 'Entropy and the New Monuments,' in *Robert Smithson: The Collected Writings*, ed. Jack Flam (Berkeley: University of California Press, 1996), p.21.

Ruth Claxton

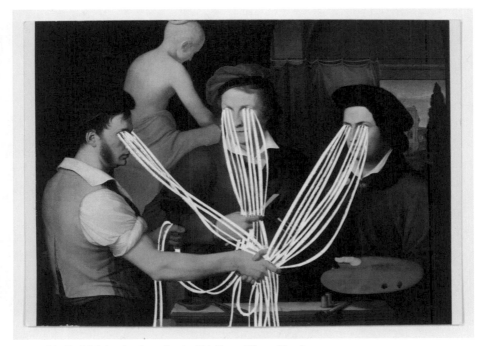

Postcard (Selbstbildnis mit seinem Bruder Ridolfo und Thorvaldsen), 2012

S M
B Nationalgalerie
Staatliche Museen
zu Berlin

Nr. 2084

WILHELM VON SCHADOW (1788-1862)
SELBSTBILDNIS MIT SEINEM BRUDER RIDOLFO UND THORVALDSEN, 1815/16
Öl auf Leinwand, 91 x 118 cm
Foto: Andres Kilger

Die Staatlichen Museen zu Berlin
sind eine Einrichtung der
Stiftung Preußischer Kulturbesitz

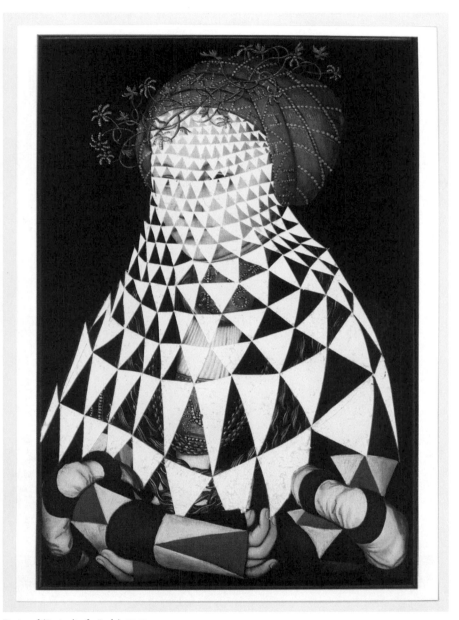

Postcard (Portrait of a Lady), 2012

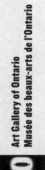

Postcard (The Laughing Cavalier), 2012

THE
WALLACE
COLLECTION

Frans Hals (1582/3-1666)
The Laughing Cavalier (P84)
Inscribed: AETA.SVAE 26 /A° 1624
Canvas 83 x 67.3cm
© The Wallace Collection, London

www.wallacecollection.org C-38513X

5050776010227

Stuart Cumberland

A Rome Diary

One of the finest descriptions of why we look at paintings is provided by Darian Leader in his book *Stealing The Mona Lisa*. The book is woven around the 1911 theft of the Mona Lisa and the unusual phenomenon that followed, the public subsequently attending the gallery curious to see the empty place where the painting once hung. Why would someone do this – visit a museum to see a place on the wall where a painting once hung? What would they expect to be seeing?

In one of the most significant parts of the book Leader suggests that when looking at art we look not for something that society forbids us from seeing, but for something that doesn't actually exist and is therefore *impossible* to see. At some level there is a shared belief that there must be something 'beyond' the surface of a painting. If the object we search for does not exist, we'll keep looking and if the work can evoke the idea of something hidden, we will be even more interested.

Any art form that accentuates the idea of a surface that we cannot see beyond will be ideally suited to catch our desire. The surface is like a veil, evoking a beyond yet withholding it: how else, indeed, could one point to an object that has no existence except by means of the veil in front of it?

Two months ago when Shaan first visited me at my studio in Deptford, London, we talked about psychoanalysis, both of us shrink users. Shaan told me that his was a strict Lacanian and would eject him from the analyst's couch as soon as he said something deemed to be significant enough to justify a pause until the next session. Shaan would rather rapidly find himself on the doorstep with a thought, which he would record on his phone. I asked to hear some and the first one he told me was 'How do you fill a hole that can't be filled?' It was this that made me think of Leader's Mona Lisa book.

A month later and I am in Rome on a three-month scholarship – January to March. I can't really work out who is footing the bill but I'm staying at the British Academy in Rome and it is pretty impressive. The weather has been great since I arrived just over a week ago but today it is raining. This means I am unable to cycle on the Roman roads amongst the traffic and historic buildings, which has so far been my main source of pleasure; that and a Raphael painting of his girlfriend, which made me laugh. I am going through a crisis (mid-life? mid-career? receding hairline?) and some days I feel fine but today I feel absolutely terrible, my body aches with longing and my brain is spinning repetitively with the same circuitous thoughts. I just want it to stop.

Work is probably the answer.

I got to Rome through my paintings – that I have made in London for the last

twenty years – but I can't see myself making any here.

Last night the artists invited to Rome gave short presentations about their reasons for being here. I decided to use the opportunity to give gifts.

Writing this is taking time. Days have past since I last added anything and I have now ordered some canvases that are arriving today (so much for not making anything here in Rome, or ever). Making some paintings is appearing to be the only thing I can do to avert my attention, to make myself disappear, to stop the circuitous thoughts. The scholars that I dine with are incredibly detached, just obsessed with their research. There is no link between their bodies and their brains. I kind of hate them and I want to antagonise them, piss them off, shove food in their faces but I suspect that their approach to work might be the only answer or solution to assuage my anxiety and depression. They are probably just not as neurotic as I am.

Neurotics are funny.

A painting by Raphael of his supposed girlfriend, 'La Fornarina', the baker's daughter, hangs in a museum in Rome. I have a poster of her up on the studio wall and I look at it endlessly. She is dead, but her smile is such that I am happy there were moments in her life, when alone with Raphael their union was silent and thought was arrested. His vision is so very sophisticated, his ability practically impossible to believe, but his love for the baker's daughter demonstrates the doubt he has in the uses of his learning. All that he wants is to maintain the simplicity of their time together.

On the way to the Borghese Villa today a bird (a robin) sat on a gated wall quite close to me and I was able to look at it for a while and my thought was arrested. Only the Veronese, amongst the paintings on the Borghese walls, in any way competed with this moment. I mean how many paintings in this gallery are of significant relationships rather than ossified stories with morals or stuffy commissioned portraits to demonstrate egos and power?

Life is so good and so bad all at the same time.

I have been in Rome just over two weeks now and yesterday I got news from England that my (Italian) stepfather died. He was 61 and it was very sudden. He took care of my mother, my younger brother and me when we left my dad about forty years ago. I am 42 now. If art doesn't arrest thought then perhaps it can open up the potential of an exit from a roundabout that currently has no exit possibilities. That is, if thoughts are painful because they circle endlessly then arresting thought is a pleasurable release but also new thought offers a way out, a new exit.

After three weeks at the British School in Rome there are faces I hate. When I walk into the dining hall and see them at the table at 8am for breakfast I am already dreading the way they'll look at me across the table and the way they talk. I resent having to turn to meet their sincere gaze and line of conversation – their absolutely, ridiculously pathetic

attempts to be funny. We share the crap bread breakfast and cheap processed orange juice that tastes like stomach bile. 'What are you up to today?' and 'what did you do yesterday?' are the key conversational offerings. I miss the deep-seated bitter humour of friends from home.

Week five starts tomorrow and I feel a little better. I have just returned to Rome from the UK where I attended my stepfather's funeral. I heard my mother crying in the room above the living room. It was the most bodily cry I have ever heard and it terrified me.

William Anskis

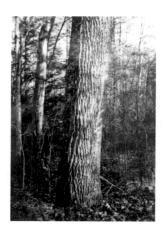

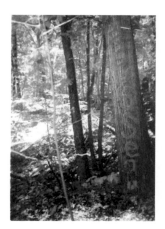

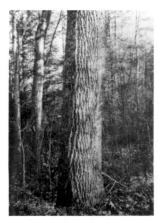

Digital photographs, Coal Region Forest, PA, 2011

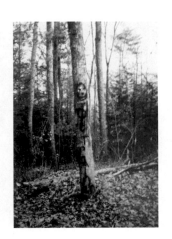
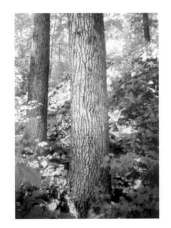
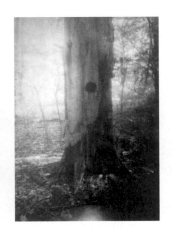
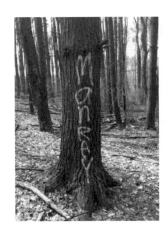
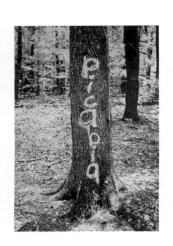
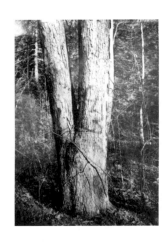

Nicholas Muellner

Mountain
Shadow Place

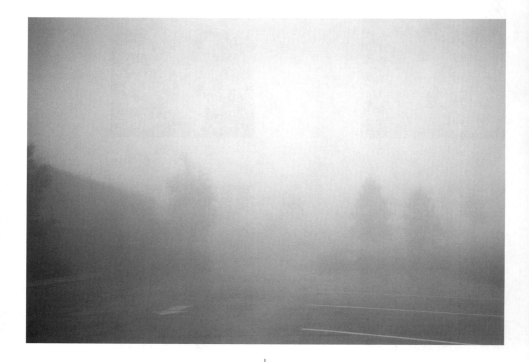

Two men and their dog. We entered the Badlands at dusk, setting up camp against the fading sun. One small cluster of tents stood across the campground, their inhabitants unintelligible in the semi-monochrome of settling darkness. Distant buffalo grazed or stood or slept, standing, along the high ridge above the site. We ate and turned in early.

Night was broken by the clatter and flash of an electrical storm, followed by a steady rain. At dawn, I unzipped a corner of the tent's window to assess the scene. Peeling back the moist nylon, a transformed landscape appeared: rivulets of mud transecting the prairie, and a looming congregation of sodden buffalo surrounding our tent. The dog saw this too, and he nearly lost his mind, crying and yelping with inchoate excitement, throwing his whole black body wildly against the flimsy green membrane of the tent. Outside, on a leash, confounded by the dual urges to cower and give chase, the hound walked cautiously across the wet grasses, as if entranced. The buffalo followed at a vigilant distance, circling us as we circled the tent, in a funny concentric dance of various wet beasts.

We pulled up stakes and retreated in the downpour to a Rapid City Holiday

Inn, watching cable TV and trying not to appear conspicuous when we ventured out for food. After three days of dank seclusion, the sun appeared, brilliantly, on the fourth. We jumped in the car and drove towards Devil's Tower – that iconic flat-topped monolith from *Close Encounters* – just across the Wyoming border.

An hour later, the near hills dropped away from the highway and the Tower appeared, fantastical in the distance. We exited north, in its direction. But the giant and strangely geometric object seemed to stay in place, flat and remote, as we approached. Twenty minutes passed, and it was unmoved, shimmering insolently in its vast rectitude. The Tower's strange vertical insistence, refusing to diminish towards a summit, and its defiant incongruity against the low landscape, meant that any estimation of scale was impossible, or ridiculously speculative. Finally, we reached the base of the park road, which turned gently uphill into a forest. There, where the sign read 'Devil's Tower,' Devil's Tower disappeared.

We emerged from the sinuous forest road onto a parking lot. To the right, a visitor's centre and some park offices. To the left, that enormous rock – spectacularly close, but no less difficult to apprehend – like a movie star suddenly entering an elevator. We parked and proceeded into this scene – of fantasy collaged against realism – on foot. An informational plaque at the trailhead sought to explain the mysterious column: the ancient impacted lava flow of a subterranean volcano, around which weaker stone had slowly eroded. We circled the tower's base. Periodically, miniature mountaineers appeared on the rock face, dangling from invisible threads at still unmeasurable heights: part-way up, towards the top, somewhere in the middle.

It felt as if the time-space continuum had abandoned these climbers in contempt at their absurd acts of will: indignant physics hanging them out to dry, without chronology or depth. I imagined they would be there, tiny and suspended, forever. And if they ever did reach the top, what manner of transcendence would they achieve on the tiny flat prairie that the retreating world had left behind? How would it feel to command such a view but to be invisible – to touch everything with your eyes without being touched back?

We decided to push on to Mount Rushmore, backwards in time from Spielberg to Hitchcock, while the weather held. Driving from the sci-fi spectre towards the histrionic immensity of those stone reliefs, we felt the giddiness of entering an image that had previously lacked depth. It was as if Wile E. Coyote had drawn a tunnel into the mountainside and we had driven through.

Back on the highway, the sky remained flawless. But as we started up into the Black Hills a tremendous fog descended, spreading and thickening around the landscape. We pressed on, convinced that the gloom would pass, just in time, in the spirit of the day's sudden and miraculous clarity.

The mist, though, only deepened: a milky swirl growing ever more opaque,

until it curdled nearly solid in the air.
The reach of our vision collapsed to
about twenty feet, and the sparse traffic
slowed to a bewildered crawl. By the
time we reached the National Park, it
was impossible to see more than fifteen
feet in any direction. The entrance rose
up against the fog with all the gothic
menace of a ghostly mansion. We rolled
up to a booth, and were greeted by a
sympathetically smiling square-jawed
Ranger. With unexpected anxiety in my
voice, I began to speak:

'Is the park open?'

'Yes,' he said, 'it is. But you cannot
see the monument at all.'

'So, is admission free?' I dared.

'No, I'm sorry. It's not. But can I give
a treat to your dog?'

'That would be great.'

And through the crack in a slobber-
streaked window, reflecting nothing but
fog, the hound received his biscuit.
There was merriment, but no resolution.
The Ranger offered to let us drive in
to circle around and exit through the
parking lot. We had come this far.
Something would redeem us.
 In the middle of the desolate lot,
I parked the car. I opened the trunk and
pulled out my tripod, erecting it on
the asphalt. I loaded my film, mounted
the camera and took in the impenetrable
enclosure of mist. Assessing the scene,
I estimated the presence of the
monumental carved faces in front of me.

I adjusted the height, levelled the device,
focused on the furthest visible object
in the frame, and took a picture towards
Mount Rushmore. At least I knew that
it was in there.
 The next morning, in the lowlands,
the sun was again brilliant. We drove
back into the hills, and this time,
the clarity held. The new Ranger had no
twinkle, and certainly no biscuits,
and the parking lot was already half full.
I parked again in the same space,
opened the trunk, and set up my camera
and tripod where I remembered placing
them before. Settling in at the same
height, in the same direction, I waited
a minute for a lull in passing cars
and ambling tourists. Then, with the
sun to my side and those great stone por-
traits completely to my back, I framed
and shot the same scene that I had docu-
mented the day before: a vista of
approaching clouds opening past the
tarmac, with an infinity of indefinite
wilderness beyond.

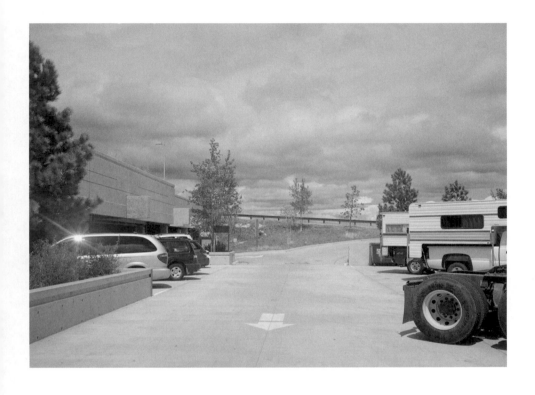

Jeanine Woollard

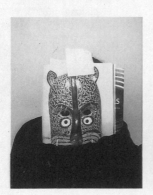
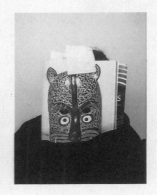

Photomaton®
Groupe Photo-Me

Merci d'avoir utilisé notre cabine
5.00 € dont TVA 19.6% - 0.82 €
Cabine N°: AM76

25/03/2011 10h53
Service consommateurs: 01 49 46 17 95

1

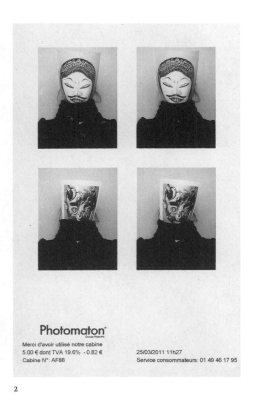

Photomaton®
Merci d'avoir utilisé notre cabine
5.00 € dont TVA 19.6% - 0.82 €
Cabine N°: AF88
25/03/2011 11h27
Service consommateurs: 01 49 46 17 95

2

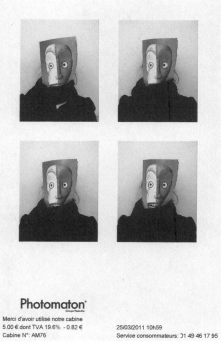

Photomaton®
Merci d'avoir utilisé notre cabine
5.00 € dont TVA 19.6% - 0.82 €
Cabine N°: AM76
25/03/2011 10h59
Service consommateurs: 01 49 46 17 95

3

1 *Henchmen Gonna Get Me Good*,
 photo booth digital photograph,
 2011

2 *Smileys People*,
 photo booth digital photograph,
 2011

3 *Two-Tone Shock and Awe*,
 photo booth digital photograph,
 2011

Benny Nemerofsky Ramsay

15 october 2012, Berlin

Dearest N

I have returned to the city after a long absence, and find myself constantly reminded of you.

It sounds strange, for you have never been to Berlin, but somehow through our correspondence I feel I have transmitted to you more than anyone else what this Paper City means to me, the many things it has represented for me over the years.

I have been feeling a kind of low-level thrill at being back, an old sensation that I associate with my first years in the city. It is a feeling that has largely disappeared for me, perhaps from cynicism over the way the city has changed, perhaps from how I myself have changed instead. The sensation doesn't have a clear, readily available vocabulary; it is as though diverse emotions and memories collide into sparks of electricity, it is a feeling of youthful excitement. Do you recognize what I am describing?

2

I was waiting for the light to change at the intersection where Skalitzer-, Wiener-, Manteuffel- and Oranienstraße meet, an illogical collection of corners that from above must look like shards of shattered glass arranged like a pinwheel. It was night, and the light rain reminded me that autumn's warmth won't last forever. I was looking up at the covered subway station that hovered a few storeys above street level, and its architecture - basic, only vaguely ornamental - reminded me of the old Storkowerstraße bridge, a structure that once symbolized everything that this city meant to me, all of the city's thrill and possibility, all of its haunting.

Before I moved here, I used to stay at the home of my friend Volker in the former East neighbourhood of Friedrichshain. At the time this residential quarter felt rather rough and spooky to me, rows of dilapidated nineteenth century houses beside imposing communist era apartment compounds. I had a special fascination with a particular gay bar in the neighbouring area of Prenzlauerberg, which featured a large back room with a labyrinth of dark corners that nourished my new-found period of sexual experimentation. I didn't have a bicycle, so the most direct route from Volker's was by train from the nearby Storkowerstraße station.

To reach the station I had to take a covered bridge - a kilometer long - over a giant industrial wasteland that was formerly an abattoir. I would traverse the bridge at night,

3

wearing boots and hungry for sex. I walked quickly, propelled by anticipation. The windows of the enclosed bridge had been rendered completely opaque by layer upon layer of grafitti, burnt out lamps left many passages of the bridge shrouded in darkness. Soon - without fail - the atmosphere of the bridge would spook me. It was something about the darkness, something about knowing that I was traversing the ruins of a slaughterhouse but could not see it. Even the name STORKOWER seemed sinister, the way a word like TREBLINKA always seemed to me to embody cold terror. So, too, did STORKOWER feel like an onomatopoeic representation of threat to my beginner-German ears.

I would break into a run. I would run like a child afraid of the dark, as though followed by a ghost or an unseen menace. I would run to bring my heart rate up, making the moment physical. I would run to implicate my body in the city's history, to evidence the way the city was changing my life and indeed, my body. I would arrive at the other end of the bridge sweating and panting, and would carry the thrill and intensity of the experience on the train ride north west, right through the threshhold of the bar.

Once I moved here I rarely ventured into that part of the city, but some years ago I took the train to visit Volker and discovere

4

the bridge had been torn down. Not only that, but the area that was once a slaughterhouse was now a series of big-box chain stores: giant supermarkets, hardware stores, a parking lot and even some kind of manicured playground. A new bridge – a fraction of the size of the original – carried consumers from Storkowerstraße station across the tracks and deposited them in the shopping area. I was shocked. I felt robbed of an architecture that was a sacred part of my personal history. I felt insulted that the history of this place – both for me and for the city – had been erased, replaced by a shiny new commercial centre, sparkling in all its primary-colour indifference and banality.

I was still young enough to have not yet learned that things really do change over time, that the more one defines oneself through attachment to things, the more one's identity will weaken. I first fell in love with Berlin because it was a place where I could feel change happening all around me. I was in love with a giant construction site: a skyline filled with cranes digging into a wounded landscape; neighbourhoods that were unrecognizable from one month to the next. It mirrored the painful process of transformation that I, too, was under~~going~~ going.

And yet it took time for me to synthesize and accept the changes that actually took place in Berlin: it changed

5

into something, the voids were filled in, the crumbling façades were renovated, the wastelands were irrigated. A spotlight was shined underground, illuminating every dark and dirty corner, until before we knew it we were all above ground, being sold our own experiences at market prices.

I'm still here, though, and I'm convinced that the ghosts that once haunted this city are, too. Perhaps they have migrated to other neighbourhoods, or have gone into hiding. I keep watch for them in the howling voice of the autumn wind, in the dust that rises from the latest construction spectacle, in the crust of glue that affixes poster to poster to poster on the streets of now party-town Friedrichshain.

Maybe one day you will come to this Paper City, N, and you will see below the city's ~~shiny~~ shining surface and sense all that lies below. Maybe you will show me what I no longer can see myself.

Yours,

B

Jeffrey Kofman

Gadhafi's Portrait

It's an ugly painting. Or it was.

Nothing more than a fourth-rate vanity portrait of a vile dictator.

But when I first saw it, his empire was crumbling around me, his houses were being looted and Muammar Gadhafi was on the run.

It was Thursday, August 25, 2011. I was on my fourth trip to Libya for ABC News covering the Arab Spring as it raged across North Africa. Spring had turned to blazing hot summer. Tunisia had fallen, Egypt had fallen and now, after a horrendously bloody civil war, Gadhafi's stronghold in Tripoli was finally crumbling.

I remember a jubilant chaos as rebels brazenly blasted holes in the walls of Bab-al-Aziza, the walled compound that was central command for Gadhafi's 41-year reign of terror. A week before they might have been shot for simply stopping in front of the compound. But that week thousands poured into the Forbidden City to see for themselves what Gadhafi was hiding from them and to celebrate his downfall. We watched dancing and looting and cringed during the endless rat-a-tat-tat of AK-47s being fired in the air.

My cameraman and I spotted a trap door in the ground. We followed some curious Libyans down a ladder and found ourselves winding through Gadhafi's fabled network of underground tunnels. His secret offices had already been plundered. A staircase led me to a crack of daylight. I pushed open the door and emerged in the courtyard of one of Gadhafi's sumptuous homes. Part of it had already been set ablaze, but the structure was concrete and the flames had faded, leaving embers smoldering from within. A handful of brazen looters were combing the undamaged sections in search of bounty, stealing chairs, pots, dishes and valueless trinkets that seemed to me to be an angry effort to claim some tangible compensation for the lives that Gadhafi's repressive regime had stolen from them.

Two men emerged from the once-sumptuous dining pavilion clutching a painting. I glimpsed Gadhafi's turbaned head as the two attacked it. They ripped the canvas, broke the wooden frame, then threw it to the ground and screamed as they stomped on his face.

I've learned in a dozen reporting trips to the Arab World that there are few greater insults than exposing someone to the bottom of your shoes. In the Arab lexicon of insults the shoe sole is an amped-up version of the Western middle finger. (Remember when an angry Iraqi journalist threw his shoe at President George W. Bush during a news conference in Baghdad?)

After a few minutes of trampling and cursing their rage dissipated and the men tossed the battered fragments aside onto a heap of debris.

When they left I walked over and picked up the remnants, still attached to the broken wooden frame. The canvas shows Gadhafi beaming contentedly in front of the vast Sahara Desert. On the

right is a pipeline, leading to a crudely-painted cornucopia of fruit. Anyone who knows Gadhafi's history will immediately recognize the imagery.

The pipeline is 'The Great Man-Made River.' Built at a price said to be in the range of $25 Billion, Gadhafi claimed it was the biggest irrigation project in the world. It brings water from deep in the Sahara to the parched population centers of Libya that huddle on the ribbon of land that traces Libya's Mediterranean Coast.

Gadhafi publicly celebrated the pipeline as proof that he really did improve the lives of his people. (Never mind that in a country of staggering oil wealth, education and healthcare barely existed and never mind that the pipeline itself is said to be forever depleting the desert aquifers.)

By any standards the painting is crude. A garish piece of private propaganda, presumably intended to remind The Brother Leader and his acolytes of his supreme goodness. How many times had Gadhafi contemplated it on his wall, finding some sort of succor in the imagery that reinforced his delusional conceit?

It was a resonant metaphor for the moment we were witnessing: time had finally caught up with an all-powerful despot.

And now his image was shredded and defiled by footprints and he was on the run. (I would return to Libya once more in October when a cowering Gadhafi was beaten, shot and killed by an angry mob of rebels outside Misrata.)

The painting never had any value, and in its ravaged state it was clearly going to disappear. I picked up the pieces, tore them from the battered frame, folded them carefully and stuffed them in my backpack.

My Libyan driver was mortified. He wanted nothing celebrating Gadhafi in his car. I assured him I would keep it concealed. He relented. I had no idea what I would do with the fragments, but eventually they travelled with me back to London.

One day a few months later I wandered into a picture-framing shop in Earl's Court in search of inspiration. I chose a simple white background and a white frame. I explained that I wanted the painting mounted so that the rips were prominent and the footprints preserved under glass.

It now hangs in my office. When I look at it I no longer see the tacky painting it once was.

As a reporter I've witnessed a huge amount of history up close, but there is something unforgettable about chronicling the overthrow of a despot. That week in August it felt like an entire nation of six million people that had been locked in a windowless cellar for four decades was finally able to emerge and see the sun for the first time. They could openly express their contempt for their oppressor without fear of imprisonment and torture. For the first time in the lives of so many of them, they were free.

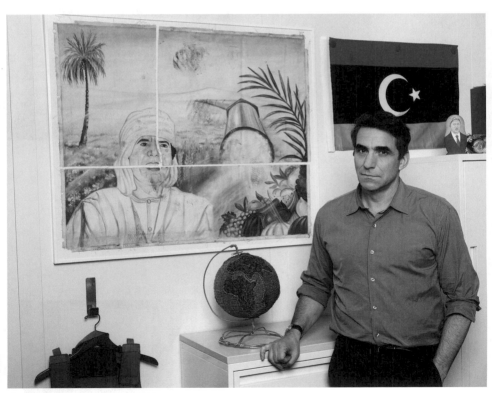

Photograph by David Edwards

Scott Leonard

1

2

3

4

5

6

7

8

9

10

11

12

13

14

15

16

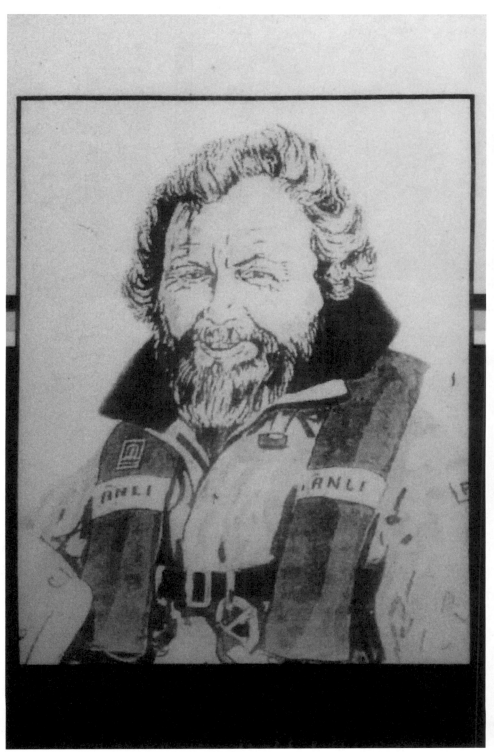

17

William Anskis is an American artist based in Brooklyn NY and Pennsylvania. His work involves found objects, paintings, sculpture, performance, and photography. Anskis uses a reductionist method of production to create new realities. Recent works have been produced by means of 'cutting away', 'shooting' and 'defacing' to create new images, meanings and correlations.
www.williamanskis.com

Ruth Claxton works with a variety of media, reconfiguring or altering pre-existing objects in order to create objects and installations which consider what it is to look, see or experience. Claxton is also Associate Director of Eastside Projects in Birmingham, a public gallery which is being imagined and organised by artists.
www.ruthclaxton.info

Stuart Cumberland is a painter based in London. For over ten years he has been making large and mostly abstract paintings using simple colours and processed gesture. The beauty and clumsiness of the human body are key preoccupations. He shows with The Approach in London and Maruani and Noirhomme in Belgium.
stuartcumberland.net

Jeffrey Kofman is a London-based foreign correspondent for ABC News broadcasts and platforms, including 'World News with Diane Sawyer', 'Nightline' and 'Good Morning America'. Kofman has reported from around the world, and covered the Arab revolutions beginning in 2010 in North Africa from Tunisia and Libya.

Scott Leonard is a branding consultant who has held executive positions in many of the world's leading advertising firms, agencies and organisations. He is Founder and Creative Director of The Champion Agency, a London-based firm that champions young creative talent and smart business.
www.thechampionagency.com

Nicholas Muellner is a photographer, writer and curator based in Central New York. His book projects, including *The Amnesia Pavilions* (2011) and *The Photograph Commands Indifference* (2009), focus on autobiographical narrative and the place of photography within that practice.
www.nicholasmuellner.com

Benny Nemerofsky Ramsay is an artist and diarist. His creative gestures in video, sound, print and textiles contemplate the history of song, the rendering of love and emotion into language, and the resurrection and manipulation of voices – sung, spoken or screamed.
www.nemerofsky.ca

Shaan Syed is a London-based artist. His studio practice focuses on painting and questions distinctions made between established notions of abstraction and representation. Syed uses methods of control and spontaneity in the painting process to speak about loss and gain and the idea of absence versus presence on the painted surface.
www.shaansyed.com

Chris Fite-Wassilak is a writer, curator and critic based in London. He is a regular contributor to Art Monthly, ArtPapers, ArtReview, frieze and Monopol. Curatorial projects include *This Way Up* a free, collaborative comic and curatorial project in Dublin (2004–2006), *Quiet Revolution*, a Hayward Gallery touring group show (2009), *PRECAST* with Dennis McNulty, and *Lta... a subtitle* with Hreinn Friðfinnsson, Damien Roach, and Megan Rooney at Maria Stenfors, London (both 2012).
www.growgnome.com

Jeanine Woollard uses sculpture and photography to recall a nostalgia for art historical tropes and artisanal methods. At the same time she utilizes mass-produced objects and imagery as a conduit for this romance. Woollard's photographs are often the documentation of carefully hashed-together detritus where any found thing or place holds the potential to be monumental. She is based in London.
www.jeaninewoollard.com

Published and distributed by FormContent
and S1 Artspace

FormContent | S1 ARTSPACE
SHEFFIELD

Distributed by AnagramBooks

Designed by Atelier Dreibholz: Paulus M Dreibholz
and Daniel McGhee

Proofreading by Oxbridge Editing

Printed by Holzhausen Druck GmbH, Austria

ISBN 978 0 9560324 1 6

This publication was made possible with the support of
Arts Council England

Supported using public funding by
ARTS COUNCIL
ENGLAND
LOTTERY FUNDED